Unlikely
Loves®

This one is for Dad, the oldest kid I know.

Library of Congress Cataloging-in-Publication Data is available.

ISBN 978-0-7611-7442-4

Design by Raquel Jaramillo, Tae Won Yu, and Netta Rabin
Photo research by Melissa Lucier

Photo Credits: © Associated Press: p. 29; Jordi Amenos Basora/Falconer: p. 114, p. 116, p. 117; Marcy Berra: p. 152, p. 155, p. 157; Jenny Brooker/Glen Afric Films: p. 160 (bottom), p. 162, p. 164, p. 167; Caters News Agency Ltd: p. viii, p. x, p. 40, p. 42, p. 43, p. 44, p. 45, p. 50, p. 52, p. 74, p. 76, p. 77, p. 79, p. 90, p. 93, p. 95; Chestatee Wildlife Preserve, Inc. "Preservation through Education", Dahlonega, Georgia USA: p. 197; Lance Clifton: p. 202, p. 205; Michael Durham © Oregon Zoo: p. 187; Edgar's Mission: p. 219; Europics: p. 30, p. 33; Jane Ferguson/Tiger Photo: p. 130, p. 133; Julie Free: p. vi, p. 54, p. 57 (left and right), p. 59; © Lauren Grabelle: p. 210, p. 213, p. 214, p. 215; Svetlana Harper: p. 96, p. 99, p. 101; Sarah Harris/Paradise Wildlife Park: p. 188, p. 191; © John Holland: p. xv; Doug Lindstrand/AWCC: p. 34, p. 37 (left and right); Christoph Matzke: p.198; Ewa Narkiewicz/elephantstay.com: p. 138, p. 139; Newspix/Getty Images: p. vii (bottom), p. 216, p. 221; Nuneaton & Warwickshire Wildlife Sanctuary: p. 124 (bottom), p. 128, p. 129; Brock Parker © Oregon Zoo: p. 182; Heather Rector: p. 46; © Tom Reed/Chestatee Wildlife Preserve/ZUMApress.com: p. 192, p. 195; © Rex USA: p. iv, p. 60, p. 63 (left and right), p. 65, p. 80, p. 83, p. 85, p. 140, p. 143, p. 144; Alex Rhodes/Lewa Wildlife Conservancy: p. 176, p. 179; Rafael Rosa: p. 172; Ross Parry Agency: p. 14, p. 17, p. 20, p. 25; Isobel Springett: p. 2, p. 5, p. 7, p. 9; © Sukree Sukplang/Reuters: p. 134, p. 136; SWNS: p. 86, p. 89, p. 118, p. 121, p. 122, p. 123, p. 124 (top), p. 126, p. 146, p. 149, p. 150; Matthew Tabaccos/Barcroft Media/Landov: p. iii, p. 160 (top), p. 165; Steph Tufft: p. 26; Glen Vena/BFF Shamwari: p. 206, p. 209; © Wales News Service: p. 66, pp. 70–71; Alexander D. M. Wilson/Aquatic Mammals: p. 168, p. 171; Janice Wolf/Rocky Ridge Refuge: p. vii (top), p. 102 (all), p. 104 (all), p. 105 (all), p. 106, p. 107, p. 108, p. 109, p. 111, p. 113; Missy Ziler: p. 10.

Workman books are available at special discounts when purchased in bulk for premiums and sales promotions as well as for fund-raising or educational use. Special editions or book excerpts can also be created to specification. For details, contact the Special Sales Director at the address below, or send an email to specialmarkets@workman.com.

Workman Publishing Company, Inc.
225 Varick Street
New York, NY 10014-4381
workman.com

Printed in the United States of America

First printing October 2013

10 9 8 7 6 5 4 3

Unlikely Loves®

43 HEARTWARMING TRUE STORIES
from the ANIMAL KINGDOM

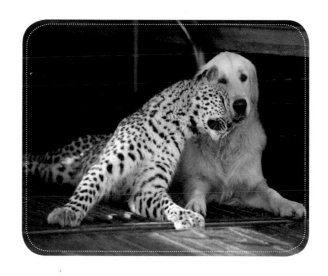

by

JENNIFER S. HOLLAND

WORKMAN PUBLISHING · NEW YORK

"Animals other than humans love unconditionally. Put your spouse and your dog in the trunk of your car for three hours, and see which one is happy to see you when you let them out."

—Master Dog Trainer David Latimer,
Forensic & Scientific Investigations, Alabama

Contents

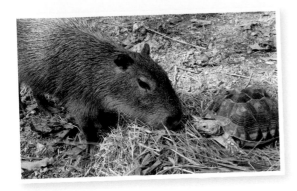

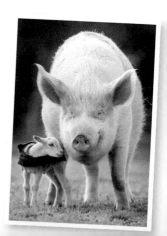

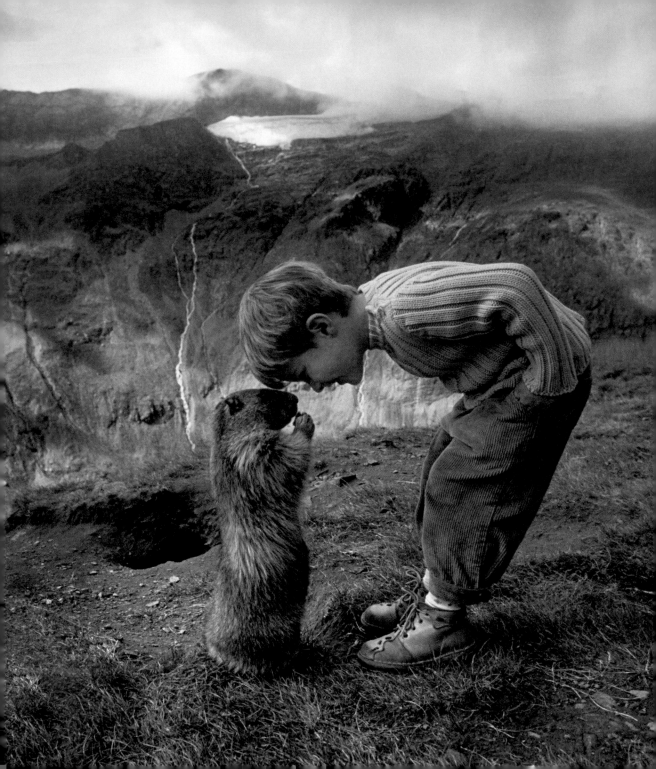

Preface

I T IS WITH GIDDINESS AND GRINS THAT I PRESENT TO YOU *Unlikely Loves*, a follow-up to *Unlikely Friendships*. First, I must mention what a wonderful response I got to that collection of animal tales, and how honored I was to know that the book touched so many people. Stories of caring behavior between animals seem to fulfill a need for joy and hope amid the struggle and strife in the world, and I'm glad to have found people willing to share such stories so I could bring them to all of you.

Based on the happy reaction to *Unlikely Friendships*, perhaps I shouldn't have been surprised when reader after reader asked me, are there more stories to tell? More photos of unexpected affection to share? Will you put them in a second volume and make us smile again? I couldn't refuse such a lovely plea.

And so, here we are. I only hope readers will have an equally happy romp through these stories as they had while reading the previous volume. And for those of you who missed *Unlikely Friendships*, I hope *Unlikely Loves* is a pleasant surprise.

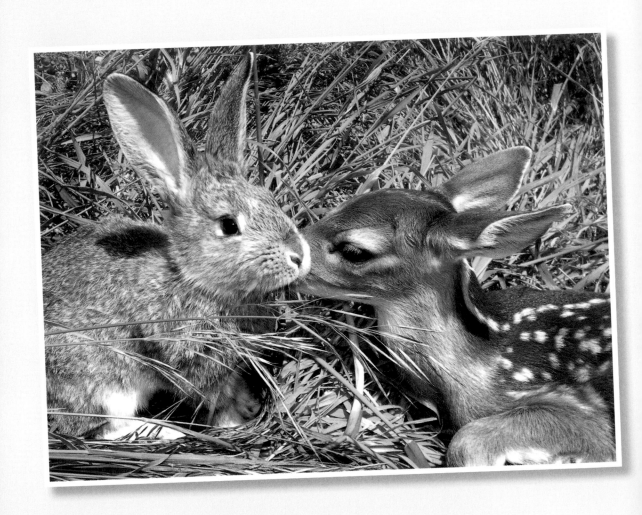

A fawn nuzzles a bunny friend in Montana.

Introduction

AS ANYONE WHO KNOWS ME WELL CAN ATTEST, **I** LOVE MY animals. No doubt I'm going to be one of those little old ladies with wild hair and a pickup full of dogs, maybe a cat or duck that follows me around. Perhaps a goat, too. I've always wanted a goat. My "eccentricities" (read: no children, animals always underfoot, fur-covered sweat suit worn in public) will be a source of caring concern for my family and friends.

While writing the previous paragraph, I got up out of my chair three times. Once to let a dog out. Once to check on a small gecko with a bum foot. And a third time to let a dog in (not the same dog I just let out). When I'm not out gallivanting around in search of stories, I do this all day between interviews, bouts of writing, and baskets of laundry. It's just part of loving the animals I keep.

I say loving because, for me, there's no word that describes it better. Love is no doubt different things to different people. To me,

with regard to animals, it's the tumbling energy I feel inside as I watch my dogs run around happily in the woods, the comfort I get from cuddling up with a warm cat as she stretches out a paw to touch my face, even the joy of glimpsing the ridiculous poses my geckos strike, hanging by one toe of those strange little feet. I love these critters. I'll always have animals in my life; they make my home a better, warmer, more affectionate place.

But when there's no human in the equation, is there love? I expect the title of this collection will make some animal behaviorists cringe. Of course "love" is a human term, describing human emotion—from the frantic pulse of a crush to the warmth and ease of a marriage long-simmered. Maybe even more so than "friendship," we cannot know whether other animals experience love the way we do. But I have no doubt that my pets can form deep attachments, can miss a partner when separated, and would grieve in some way if that partner died (heck, even birds like magpies have been shown to mourn).

Still, love is tough to define, even for us. I wouldn't claim to know whether the term applies directly to a cat's or dog's or chicken's affections, though as discussed with numerous experts in *Unlikely Friendships*, much of the circuitry that lets us love is present in other species. Less developed, perhaps, but it's there. Evolution tends to reuse good bits and pieces, like the emotions that help us thrive and reproduce, rather than starting from scratch with each being. So the overlap between what we do and what other creatures do is considerable.

Time and again we read reports of animals driven to help ease

another's pain or protect another from danger. One story I came across while researching this volume was of a dog pulling his owner off the train tracks where she'd collapsed; the dog was hit as a result (but survived, fortunately). There's a well-watched video on YouTube of an orangutan saving a duckling from drowning. A female gorilla at a U.S. zoo famously grabbed up a child that had fallen into the pen, shielding him from the other apes until keepers could rescue him. And so on.

*Intra*species care (care of your own kind) is of course common, and makes utter sense evolutionarily speaking. Squirrels will attack crows feeding on familial roadkill or a dog threatening their young, and dolphins are reported to bite through harpoon lines to save their own. Primatologist Frans de Waal tells us in his book *Good Natured* that whales will put themselves between a hunter's skiff and an injured whale (or even try to capsize the boat) so predictably that whalers take advantage of it. And there's a YouTube favorite showing a dog weaving in and out of speeding traffic as it drags its injured friend or relative from further danger—a seemingly moral, even altruistic act (though as is typically the case with animal behavior, there's no consensus on how to define the deed). Finally, I must mention that my husband, as a child, discovered his pet raccoon whining over a hat made from a raccoon pelt. The animal was clearly distressed to find something so familiar yet so . . . dead.

I think my dogs would protect me if an intruder entered the house, but I can't deny that they probably "love" their squeaky toys as much as they "love" me. What I mean to them on a deeper level is a mystery.

But that's okay. In fact, part of what's so amazing about love is how it perplexes us. Indeed, after an article came out in *National Geographic* back in 2006 examining the science behind love—what we can learn from MRI images of the "madly in love" brain, the chemical pathways of desire, the biological answer to why love fades with time—letters from readers poured in, expressing distress at the attempt to quantify and demystify our sweetest emotion.

All that said, here is a book about animals entitled *Unlikely Loves*, in which I present a batch of delightful stories of unexpected affection between nonpeople. (As in my earlier book, a few very special people-animal tales snuck into the mix, but the majority are about nonhuman creatures. Also as in the last book, a lot of dog stories made the cut; canines may just be the most empathetic animals out there.) The behaviors we see in these cases certainly resemble key characteristics of love in the human world—never wanting to be apart, protecting another from insult or harm, watching over another during illness, providing motherly (or fatherly) care, and sometimes not letting go even when love goes unanswered. I'm not trying to prove that Fred the dog truly loves Blanche the goose, or even that my dog's tail-wags and messy kisses mean anything more than he's hungry. But it's fun to imagine—and not an unreasonable notion—that there's more to it than that.

I spoke with Tara Brach, PhD, a highly regarded teacher of Buddhist psychology and meditation, after happily learning that she had referred to *Unlikely Friendships* in one of her lectures. I treasure what she said about why these kinds of stories move us: "There's something very

fundamental about love, and it shines through in different species in different ways, taking different shapes. But when you see creatures caring beyond their narrow affiliation, it resonates as a more universal phenomenon. It makes you trust the essential goodness of life."

That goodness of life, sadly, is something that's often hard to see in the dense fog of tension that surrounds us. But I think it's always there, within reach. It's present in the generous people who take needy animals into their homes and hearts. And it's present in moments of caring between two other species, whether the animals are being kind through parental instinct or some urge that's inexpressible. As each new case emerges, we're lifted a little further above the muddle, giving us a glimpse of the sun. Love, or whatever you want to call it, is a true life preserver.

The author and her dog Tai

Whatever term is used to describe animal affection, says Brach, "if it helps one recognize his or her own tendency for passion and kindness, that recognition will call those feelings forth more. These stories invite us to see what's possible. They're part of that momentum toward a more compassionate world."

Who Loves You, Baby?

> "There is no instinct like that of the heart."
>
> —*Lord Byron*

IS THERE ANY LOVE STRONGER THAN THAT OF A PARENT FOR HIS OR HER CHILD? In this section, I pull together some of my favorite cases of one animal playing a maternal or paternal role in the life of another. For us, true parental love enhances a child's life in countless ways, and those who grow up without it may struggle as a result. But in the nonhuman animal world, particularly for mammals, the commitment of the parent doesn't just improve the course of a young animal's life; it is often paramount to survival.

The twist in this collection, of course, is that the animals doing the parenting have no DNA ties to the creatures they are protecting. That's what I cherish about these tales. Never mind evolutionary explanations—the animals seem to be responding to something deep within themselves.

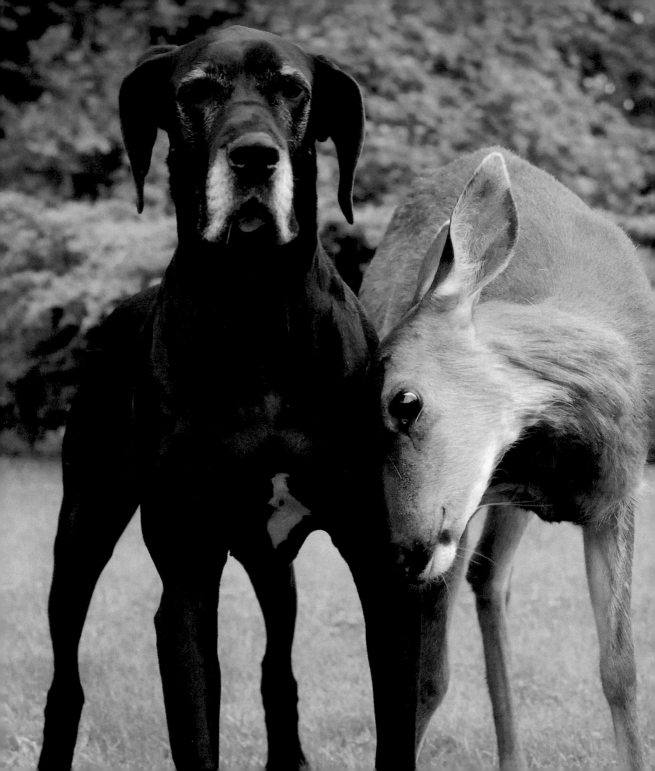

The Great Dane and the Fawn

I MET A PAIR OF GREAT DANES IN COSTA RICA ONCE. THEY lived at a B&B near Lake Arenal. What I remember about them is not just their impressive dimensions, but also their immediate comfort with and sweetness toward strangers. If in the morning you sat on the chairs of the front porch to watch the tropical birds at the feeder, a Dane that barely knew you would amble over and sit in your lap. Literally. Front paws on the ground, butt settled squarely on your thighs, it turned you into a human chair. No warning, no questions asked. Sit. Stay.

So when I heard about the Dane that laid its affection on a tiny fawn, I was relieved to hear the dog didn't mistakenly crush the little animal with the weight of its love. In fact, the friendship

between dog and deer, though rambunctious for a time, was as tender as it gets.

Dane owner Isobel Springett told me the story in such nice detail that I wanted to share many of her words.

But first, some introductions. There's Kate—that's the Great Dane—and Pippin, the abandoned fawn. Isobel got Kate as a six-month-old puppy. The family lives on Vancouver Island in Canada; this love story takes place at the Springett home at the edge of a small forest.

"Kate was the type of dog left behind after people pick from the litter," Isobel recalls of her loving canine. "She was the plain black one, very scared—when I got her she wouldn't even go into the house. She'd do the big *flop* and lie there until we carried her inside. But within two weeks she was over her fears, not afraid of anything. I was absolutely in love; she was amazing."

And then Pippin came into Isobel's and Kate's lives. "It was early June when I first saw the tiny newborn fawn playing in one of our buttercup meadows under the nervous gaze of its mother," Isobel says. "That was nothing new, but it was always a pleasure to see."

Two days later, she says, she began hearing bleating sounds like a baby crying, distress calls, coming from nearby. When she and Kate went for a walk to their barn, "Kate discovered the fawn curled up on the edge of the driveway. She was fascinated!" Isobel left the baby there to see if the mom would come back for it. But a day later, she realized the fawn had been abandoned. It was a hot day and the baby wasn't

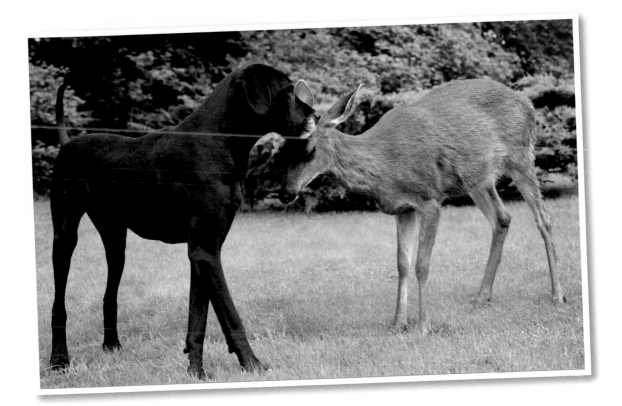

going to survive much longer without something to drink, "so we finally gave in and rescued it."

And that's where the Kate–Pippin story truly begins. Says Isobel, "Kate instantly took to the fawn, as if she'd been waiting for this moment. She went over every inch of her, and gave gentle little licks here and there. Pippin definitely got comfort from this and nestled in close to Kate's side."

The fawn was dehydrated and weighed less than five pounds, so Isobel started hydrating her with saline water from an eyedropper and then moved to milk replacement in a bottle.

Meanwhile, Pip began exploring the house and getting to know Kate better. Isobel didn't want to make a pet out of the wild animal, so she intentionally didn't handle her more than necessary. Instead, she let the dog do the touching. "Kate proved her value as a surrogate mother. Having a four-legged mom, even if it was a dog, was far superior to a two-legged one."

Pip's routine, like most babies, was sleep, eat, and poop, then sleep some more. "Every time she woke up," Isobel says, "she'd look for Kate. And Kate seemed to realize this little thing was depending on her, and acted as if it was her job to help me feed her. She'd stand like a statue while Pip bunted her and fussed about."

Pip soon knew the sounds of bottle preparation and would get excited to eat. One day Isobel heard Pip "racing in circles around the dining room table"—much like a wound-up puppy. "I knew then that she was going to be okay."

With the fawn growing stronger every day, she began to follow Kate outside and might spend an hour poking around in the garden, always within a nose of the dog. But once she was comfortable outdoors as Kate's shadow, the fawn's wild instinct crept in: "Pip decided she'd had enough of the house and wanted to sleep in the woods, like a real deer," says Isobel. One morning Isobel saw her curled up at the edge of the woods with a wild deer standing nearby. "This was the first time I'd seen Pip associate with another deer. As I watched, the deer wandered into the woods and disappeared. I realized then that she had a chance at being integrated into the wild herd."

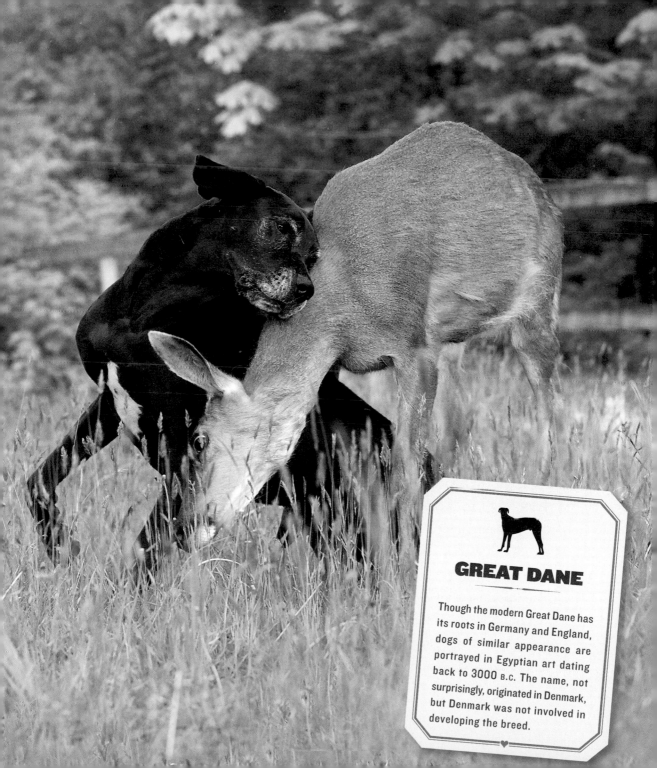

GREAT DANE

Though the modern Great Dane has its roots in Germany and England, dogs of similar appearance are portrayed in Egyptian art dating back to 3000 B.C. The name, not surprisingly, originated in Denmark, but Denmark was not involved in developing the breed.

DOMESTIC DOG

KINGDOM: Animalia
PHYLUM: Chordata
CLASS: Mammalia
ORDER: Carnivora
FAMILY: Canidae
GENUS: Canis
SPECIES: Canis lupus
SUBSPECIES: Canis lupus familiaris

But she wasn't ready to leave her comfortable home and surrogate mom just yet. Pip spent many hours playing and grazing on the front lawn that summer as Kate lounged nearby. The dog took the relationship quite seriously. "She would get a little worried if Pip was gone longer than usual, or if she suddenly decided to leave. But deer are incredibly independent, a fact that helped enormously in Pip's survival." To Kate, the behavior didn't make sense since pups always stay with their mom. "If Pip wandered off, Kate would wait for ages for her to come back."

Eventually, the fawn began spending more time with the wild deer drifting among the trees, floating effortlessly between her wild and domestic lives. When winter came, Pip would show up on the wooden deck, her hooves *click-clack*ing her arrival, wanting to come in to visit Kate and have a bite of grain and bread.

And in the spring, Kate and Pip's bond continued to grow, the two walking in the woods together as if it were perfectly normal, even joining forces to scare away a bear that showed up on the property. "The bear stood on its hind legs not twenty feet from us," Isobel recalls, "and Kate and Pip shot after it like bullets. I was stunned! They chased it for about a hundred yards until it ran through the fence and was gone. The look on Kate's face when they returned was priceless. They both seemed to think this was perfectly normal behavior!"

Meanwhile, even as Pip embraced her deer-ness more and more, Isobel marvels that this near-wild animal and the giant black dog who

raised her continued to share licks, nuzzles, and rambunctious play. "I knew that there was so much more to their relationship than just one animal that helped another in need. This was really special."

Pip has since given birth to a number of fawns of her own, and the wild play with Kate has eased into more gentle communications between them. But Isobel says they continue to show a loving familiarity when Pip comes around, and their youthful frolicking of days past always sticks in her mind. "They developed a body language that's a compromise—not quite deer, not quite dog," she says. "Something in between that only they share."

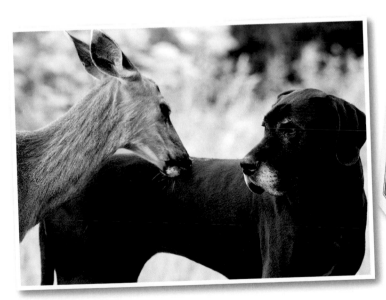

COLUMBIAN BLACK-TAILED DEER

KINGDOM: Animalia
PHYLUM: Chordata
CLASS: Mammalia
ORDER: Artiodactyla
FAMILY: Cervidae
GENUS: *Odocoileus*
SPECIES: *Odocoileus hemionus*
SUBSPECIES: *O. h. columbianus*

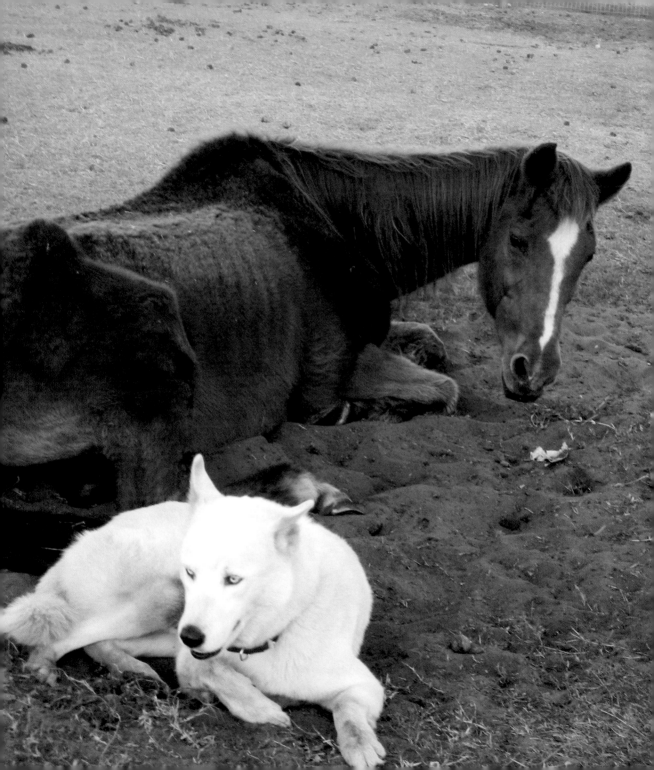

The Old Mare and the Dog

AT A SPECIAL PLACE CALLED MISFIT FARM IN FLORIDA, animals get a second chance at life . . . and sometimes at love when they need it most.

An old Arabian mare named Candy came to the farm after her owners lost interest in caring for her. She was in poor shape after years of neglect, but Mindy Ziler and her husband were good with horses, having two of their own already, so they offered to bring the animal home. They cleaned her up, fixed her worn hooves, and fed her well. The Zilers grew very attached to the old horse, and she was comfortable in her new life, settling into the rhythms of the farm.

A beautiful dog named Woolf, meanwhile, was a long-standing resident at Misfit. Mindy's husband had discovered the white

shepherd–husky mix some years earlier—homeless, collar-less, and chasing squirrels in a parking lot near his workplace. With a single "Here, boy!" he had the dog in his arms, and brought him to the farm intending to find him a new home.

"But I couldn't let him go," Mindy says. He turned out to have an incredibly gentle demeanor and sweetness with children; he seemed the perfect candidate for being a therapy dog. So Mindy began the required training, which the dog took to with ease. "I don't know what it is, but he has some magical connection with people," she says. (He now regularly visits needy people of all sorts, and is even a courtroom companion for children facing traumatic trials.)

With a heart that kind, maybe it isn't surprising that Woolf also bonds tightly with nonhuman animals in need.

"Candy was old when we got her," Mindy says, "but last winter her age really started to show. She began lying down a lot and didn't seem to feel well. And that's when Woolf suddenly took to her." Mindy's dogs aren't usually allowed in with the horses, but they dug a hole under the fence so Woolf could squeeze under and lie down next to her. And when another animal went to inspect Candy, "Woolf barked and bared his teeth—I'd never seen that kind of aggression from him before."

Now, Woolf had never paid much attention to the horses before, except to chase them along the fence. But as long as Candy was unwell, the dog would run to check on her each day and then refuse to leave her side. "I think he sensed Candy was sick—he seemed to smell it

in her," says Mindy. "He was going to lie there and protect her so she could rest, so she could eat, so no one would bother her. If she got up to graze, he'd stay where he could see her."

Candy, for her part, let Woolf be her companion and protector even though normally she was grumpy toward the other animals. Whether the dog was lying with her or sniffing her or even nibbling at scraps from her food, she seemed content, even welcoming, of his attention. "He comforted her," Mindy says.

But eventually the horse's stubborn strength wore down and her owners decided they had to put her to sleep.

The day the family buried Candy by the barn was a somber one. "Woolf went over to the area where we had kept her, sniffing around as if looking for her. He could tell she was gone." Mindy hopes he knew he'd helped carry her through her end of life and that she was no longer in pain.

"Looking back, I absolutely think there was a special affection there," Mindy says. "Nothing bothers this dog. But when Candy was sick, he was defiant with me when I wanted him to come in or get away from the mare. He'd give me a look that clearly said no! He wanted to be with her. I think he knew she was dying and wanted to ease her pain."

SHEPHERD–HUSKY

The most decorated war dog of World War II, named Chips, was a mix of these two wonderful breeds.

♥

Mindy says since Candy died, Woolf has begun showing special interest in her cat.

Uh-oh.

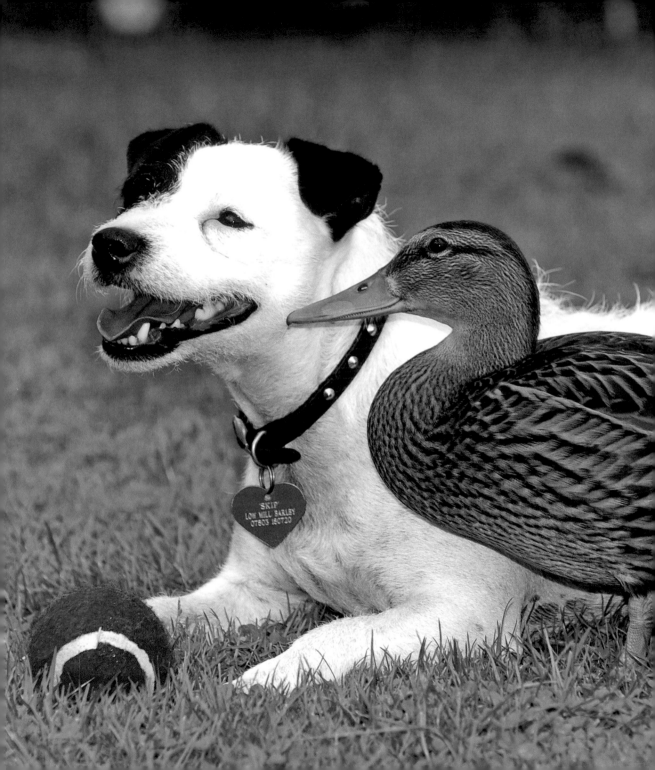

The Terrier *and the* Duckling

IF A DUCK GETS LOST IN THE WOODS, WILL IT MAKE A sound? And if it does, will someone come to see what all the quacking is about?

The answers in this case are yes, and yes. Very fortunate for little Fifty Pence, squeaking away on a wooded path, her life certainly headed for a swift end were it not for the kindness of strangers.

Here is Skip the terrier, born to working-dog parents (and so with the killer instinct in her DNA) and trained to hunt. Yet this pooch showed loving-kindness to the feathered morsel that would have fit as nicely in her mouth as cuddled against her side.

Now, fortunately for the outcome of this story, working terriers aren't duck hunters. In England, where our characters

found each other, the dogs are trained to go after fox, rodents, ground-hogs, and other burrowing creatures—sometimes actually following them underground. Ducks and other birds just aren't on the list of quarry.

Still, you wouldn't expect a terrier to be a duck's surrogate mom and BFF.

The bird, a mallard duckling, was just a day old when a couple walking their dogs in a Yorkshire wood near Eggborough noticed her sitting alone on the ground. They decided to continue their stroll, hoping the mother duck would come back for the lost baby, but on the return the ball of fluff was still there—and this time she was about to become lunch for a fox. Eager to save her life, the couple scared off the predator and took the duckling to a local woman known to care for abandoned wildlife.

When Annette Pyrah answered her door that day, she didn't know a duckling was about to change her life. She now runs a small animal rescue shelter for British wildlife out of her home in Barlby, a village in North Yorkshire, but at that time she'd been training to be a legal secretary. It was after the duckling's arrival that she began accepting all kinds of creatures, and she soon became their full-time caretaker, her legal career diverted.

Annette called the animal Fifty Pence after her coinlike smallness. To make the bird feel at home, "I used a feather duster and mop head to make a nest—keeping her warm like a mother duck would—in my conservatory," she says. "It's a trick I often use for abandoned birds."

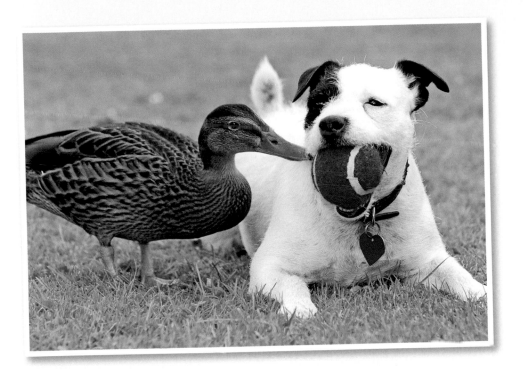

Meanwhile, she noticed that her dog Skip was keeping a watchful eye on the orphan.

Soon after hatching, ducklings will begin following and learning from whatever bigger animal they see first, typically the mother bird (what biologists call filial imprinting). Without a mom in her sights, Fifty Pence would be seeking a replacement parent. Annette didn't want the duck to imprint on her—because that would make it hard to later release the animal back into the wild. "But I needn't have worried," she says, because, like the dog for the bird, "Fifty Pence only had eyes for Skip."

With the intrigue obviously mutual, Annette finally decided to let the duck out in the yard with her two dogs. "She went right to

MALLARD DUCK

KINGDOM: Animalia
PHYLUM: Chordata
CLASS: Aves
ORDER: Anseriformes
FAMILY: Anatidae
GENUS: *Anas*
SPECIES: *Anas platyrhynchos*

Skip—ignoring my other dog, Holly—and wanted to play." Wasting no time on formalities, the duckling began chasing Skip around, grabbing at her tail. As she got a little bigger "she even tried to fetch," Annette says. "I'd throw the ball and she'd do sort of a flying run, flapping her wings, so she could get to it before Skip did. Of course, she couldn't pick it up in her beak." The bird also took to Skip's bed, and the two shared it, nestled in together as Fifty Pence groomed the dog with gentle nibbles and pecks. The dog seemed to appreciate the attention and remained soft-mouthed in return—even when the pecking clearly became a bit annoying, Annette says.

"What touched me most was the trust this little duck showed," she says. "Here's this tiny, vulnerable thing putting her faith in an animal that might have been her enemy—it's like going to a lion for affection! I suppose she was lonely and wanted companionship, and normally she'd have had her mother and siblings. So she turned to Skip. And for some reason, this dog with the instinct to attack decided to be loving instead."

Annette says her plan was, eventually, to take Fifty Pence to a nearby pond where other mallards congregated with hope that the bird would recognize and join her own kind, maybe even find a mate. (Annette had been bringing pond algae to the duck to eat so she'd get used to natural food.) But then, about three months after the duckling's arrival, came an upsetting day.

"I'd gone out shopping, leaving the animals playing ball in the yard," Annette recalls. "And when I came back, Fifty Pence was gone. I found out later that some teenage boys had been over chasing and scaring her, and she'd flown away." She says that both she and Skip went looking for the duck. A neighbor claims to have seen her on a nearby street, "but we couldn't find her. We all felt lost—she'd been part of the family. I think Skip was really sad; they'd been so close."

Before that day, "she was flapping her wings, almost ready to go, and I knew someday she'd leave us," Annette says. "It's a very special experience to rehabilitate animals, but when they're weaned, you have to take a step back and let them know that humans aren't usually good news for wild animals. That's what I always try to do." But this wasn't how it was supposed to happen. "It's very upsetting not knowing if she's okay, but we're hopeful she's fine and will come back in the spring—fingers crossed. I do have a big pond here, so maybe she'll return."

Until then, Annette and no doubt Skip, ears perked and nose up, will be watching the sky for a familiar shape and affectionate quack, Fifty Pence coming home to the family who loves her.

WORKING TERRIER

Quick on their feet and sensitive of nose, terriers of many sorts have long been the darlings of fox hunters, though the act of hunting fox with dogs—whether for sport or to control fox populations—continues to stir up considerable debate; not all agree it is humane.

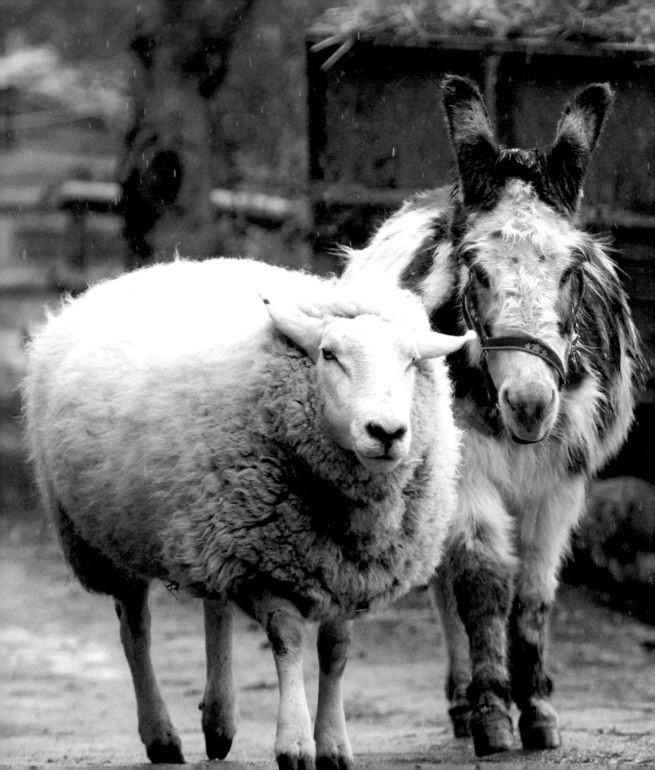

The Donkey
and the Sheep

THERE MAY NOT BE A WEDDING VOW ABOUT LEAPING IN front of an oncoming train to prove your love. But it is probably fair to say that most of us, in an uncomfortable or scary situation, would try to protect a loved one from insult or harm— even if it meant putting ourselves in a tough spot.

Taking risks to save someone special is by no means a people-only deed. Social animals of all kinds are regularly put to the test in the wild, defending territorial and familial boundaries, fighting rivals over mates, sending up warning alarms, and scooping up their young and running from danger. And even our more domesticated friends, in the least likely scenarios, can prove to be heroes at heart.

Meet Dotty. Dotty is a donkey, round and content from years of excellent and affectionate care by her owners. It's amazing to see her now and know of her history. As just a little tyke she had been left tied by the side of a country road in a Yorkshire village, clearly abandoned. A man driving by glimpsed the animal and was upset by how emaciated and wobbly she was. Ever the animal lover (and married to another one), the man couldn't leave her there to die, so he loaded little Dotty into his truck and whisked her home to live with him and his wife, Ann, on their 50-acre farm. There, the donkey grew and thrived.

Also at the farm was Stanley the sheep. He was a marshmallow of a creature, woolly and round, with a smooth white face, his ears always a-twitching this way and that. He, too, had a bit of a rough start. He and brother Sidney were orphans that Ann brought up on the bottle.

From early on, Dotty and Stanley shared a stable and field with each other and the menagerie of other creatures that Ann cares for— llamas, goats, rabbits, horses, and chickens, to name a barnful.

"Dotty and Stanley were good friends from the beginning," recalls Ann. "They'd go out in the field and play together, along with another sheep named Simon. The two sheep would chase Dotty, then Dotty would chase the sheep. They'd run around and wrestle—it was so fun to watch. They're a bit old for that now, but they used to do it all the time." The fact that both animals are "too old" for roughhousing now is wonderful news, because that means both survived a horrible ordeal that took place a few years back.

"It's still very vivid," says Ann. "These kinds of things tend to stick in your mind, don't they?" It was a Saturday afternoon around five, she says. The animals were out in the field, and she was in the yard nearby. "Suddenly, there was commotion at the gate, and Stanley came running like I'd never seen before. He was literally dragging a dog. It was a pit bull, and he had his teeth dug into Stanley's neck and wasn't letting go."

There was a terrifying frenzy, she says, as the sheep struggled and the dog bit harder. Ann, frantic to help, rushed around looking for something to use as a weapon against the offender. She grabbed an old piece of drainpipe and rushed to help Stanley.

"But then came a scream of rage," Ann says. "It was Dotty! I can't describe the sound any other way—I'd never heard anything like it. She came tearing down the field in hot pursuit of the dog and leaped on him, digging her jaws into his neck. The three of them were locked together like that for what seemed like a long time. It was so frightening."

Ann moved out of the way when she realized her efforts to help were futile. And anyway, Dotty seemed to have the upper hand. "She was doing a better job than I was," Ann remembers. The pain from the donkey's tight clamp must have finally gotten through to the dog, because he suddenly let go and ran off. But he wasn't done yet; on his way through the field he actually bit two horses, one just a pony. Then, finally, he was gone.

SHEEP

KINGDOM: Animalia
PHYLUM: Chordata
CLASS: Mammalia
ORDER: Artiodactyla
FAMILY: Bovidae
GENUS: *Ovis*
SPECIES: *Ovis aries*

DONKEY

KINGDOM: Animalia
PHYLUM: Chordata
CLASS: Mammalia
ORDER:
Perissodactyla
FAMILY: Equidae
GENUS: *Equus*
SPECIES: *Equus
africanus*
SUBSPECIES: *Equus
africanus asinus*

With Dotty standing by "looking concerned," Ann says, "we quickly got Stanley up and to the vet. He was in bad shape and the vet wanted to put him to sleep." But Stanley was a pet, and the family didn't want to lose him. "We just wouldn't have that. So instead we had them take out a broken tooth and clean him up and we took the poor thing home."

Stanley was paralyzed on the bite side of his face for about a year, and couldn't eat properly. Sheep, like cows, regurgitate their food and re-chew it (called chewing their cud), but his food would fall right out because his face muscles weren't working. "He struggled," Ann says. But she kept Dotty and Stanley together, as they had been before the incident, to avoid changing the routine in a stressful way. It seemed to be the right decision. After a while he started to heal. And eventually, he made a full recovery, with Dotty by his side—sleeping "in a heap" with Stanley and another sheep, eating, and walking in the field together.

"I think without the love and support of us and of Dotty, he wouldn't have survived. He would have died of shock."

Recently, Dotty was recognized for her heroic act by the PDSA (People's Dispensary for Sick Animals), a well-known veterinary charity in the U.K. The award usually goes to dogs that have served in the military, but this time a brave donkey got the prize, the first time a nondog was acknowledged. "She had the TV people come and see her

about it," says Ann, "but at that point I think she was just fed up with the attention. Too many cameras in her face!"

Who can say why Dotty made the ultimate sacrifice, putting herself in a dangerous situation to help Stanley? "I myself certainly thought twice about getting near that dog," Ann admits. "But Dotty didn't. She saved him without worrying for herself. That's love, I think."

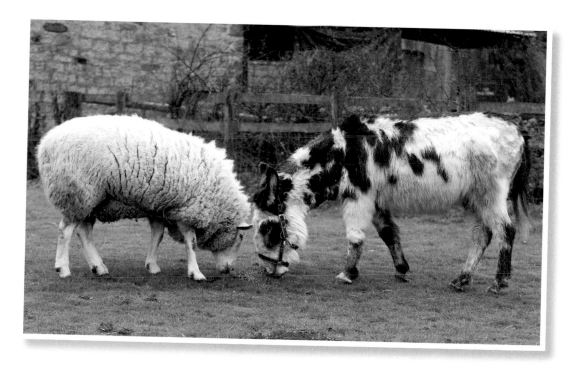

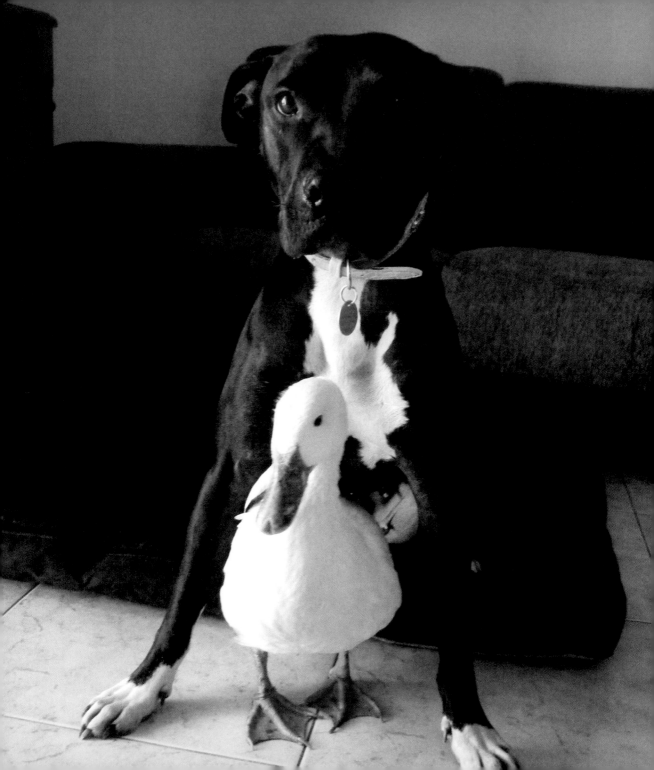

The Pekin Duck and the Pit Bull

ON A FARM OUTSIDE SOUTHAMPTON, HAMPSHIRE, ON the southern coast of England, a woman named Steph Tufft gazed across a sea of white ducks, some 3,000 in all. Each was destined for a dinner plate (these were Pekin ducks, after all). One little quacker with a yellow Mohawk caught her eye. "That's the one," she said, sealing the animal's fate. But in this case it was a happy fate. Steph didn't want duck for dinner; she wanted a duck as a pet. And Essy, as Steph named her, would soon be stroked, babied, and loved by her owner, her family, and an unlikely love.

The first glimpse most people get of Essy nowadays is a white blur on a leash sandwiched between two dogs. It may require a second look to sort out the strange tableau, a bill among pup snouts,

webbed feet dancing between canine paws, the leashes in Steph's hand as she maneuvers the pack (flock?) down the sidewalk on any given Sunday afternoon.

The two dogs, a pit bull Raksha and a Staffordshire bull terrier mix Double D (for "deaf dog"), belonged to Steph's husband when she met him. So the next thing to do after purchasing her duck was to introduce duck to dogs. "The plan was to let the dogs sniff her and then put her in a separate area, not to rush things," she says. "But as soon as she met Raksha, she latched on."

Early on, Steph would try to keep the animals separate, dividing up a hallway with a gate, and later a tall bit of fence. "We thought it was best to give different animals their own spaces. But no matter how high the barrier, they'd scale it and would be happily sleeping together when we got home." (She's still not sure how they did it.)

The group will go to the beach and when the dogs run off to swim, Essy follows along, quacking crazily, though she can't really keep up. And after all her time around dogs, the duck now likes dog biscuits better than bread.

Then there was the incident that really illustrates the bond between Essy and Raksha. One night, Essy was attacked by a wild dog. "It was horrible," Steph recalls. "Her chest was ripped open; we were out in the sticks and it was late—I had to stitch her up myself and hope for the

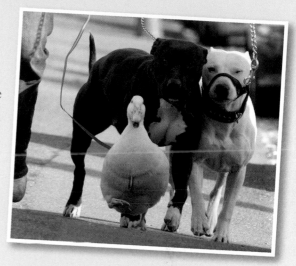

best. It was touch-and-go all night; we weren't sure she'd survive." Steph and her husband put Essy next to their bed so they could keep an eye on her, "but she wouldn't settle. My husband suggested we bring Raksha in to keep her company. And as soon as we did, Essy nestled right in and calmed down."

For twelve nights, Raksha stayed with Essy, licking her, mothering her, and helping her heal. "Raksha kept checking and licking the chest area where she'd been injured—it was really amazing. She seemed to know that part of Essy needed tending," says Steph. "Essy might not be with us now, might have given up, if she didn't have Raksha. The dog gave her something to live for."

Steph, who was a vet nurse for years and has seen lots of animal connections, says she genuinely thinks there is something like love between Essy and Raksha, it's such a close bond. "They're so affectionate; they seem to have a need to be with the other one. It's like nothing I've ever seen before. The duck and dog literally latch on to each other; if we're sitting watching TV, the two will curl up on the bed and you won't hear from them for the rest of the night.

"They're quite happy to be together," Steph says, "just the two of them."

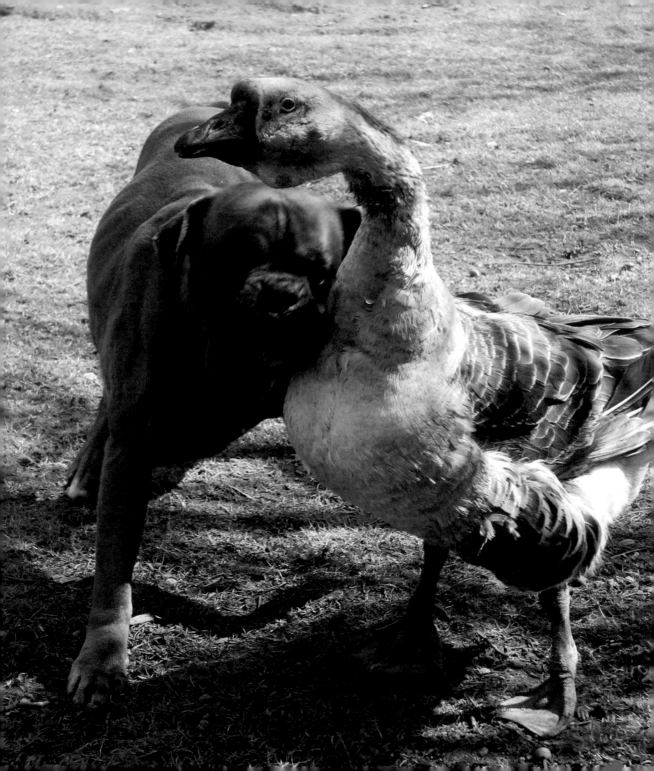

The Blind Boxer
and the Goose

IN A TINY TOWN IN **POLAND** CALLED **PONIATOWA**, A WOMAN
named Renata Krause makes her home. She has an old house
and barn in an old neighborhood filled with old houses and barns, on
a narrow street where everyone knows everyone else but people tend
to keep to themselves. Her home has all the typical things homes
have, but then there are a couple of oddities. Bak (pronounced *Baks*)
is a boxer, and he's completely blind. And Guzik is a goose who is
happiest when chasing everyone away. Except for Bak. Bak can stay.

So, Bak and Guzik: What's their story?

Renata got Bak as a puppy, adopting him from a friend. Bak
was a roamer from the start. He'd jump the fence in the yard and
go into the village looking for a playmate.

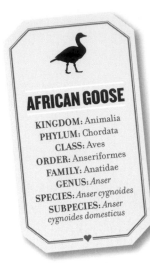

AFRICAN GOOSE

KINGDOM: Animalia
PHYLUM: Chordata
CLASS: Aves
ORDER: Anseriformes
FAMILY: Anatidae
GENUS: *Anser*
SPECIES: *Anser cygnoides*
SUBPECIES: *Anser cygnoides domesticus*

He also grew quite big. Renata's neighbors, unfortunately, weren't happy to see this hulking, unchained animal when he'd show up on their property. But Bak was persistent; when Renata raised the fence, he simply dug under it to escape. And off he'd go.

One day, when Bak came home from his adventures as usual, the dog had gone blind! Someone, most likely, had purposefully blinded him to send an angry message to Renata that the dog's wandering was no longer tolerable. She felt horrible about his injury. The vet checked him out, suggesting maybe Renata should put him to sleep. "But he was still a young dog," Renata says. She was a nurse herself, with a nurturing heart. "I just didn't want to do that!"

Meanwhile, Renata had to go to Italy for a time, so her mother came to stay at the house in the village. When Renata got home, there in the yard stood Guzik. Guzik the goose was just a little thing; he had been rejected by his mother. So Renata's mom had agreed to take him. (His name, Guzik, means "Buttons," given for his penchant for trying to bite buttons off people's clothes.)

Before Guzik came, Bak had been trying to adapt to his blindness, with limited success. "He'd bump into everything, and seemed unhappy and helpless," she recalls.

But the goose that didn't seem to like anyone decided to take the blind dog under his wing. Guzik now "tells" Bak when there's food to be had and leads him to his bone and his water bowl. He wakes up the dog

in the morning and even helps the pup fulfill his "watchdog" duties. "The goose actually runs to the gate when the mailman comes or the bread is delivered and makes a lot of noise, runs back to Bak, and then Bak follows and barks, too."

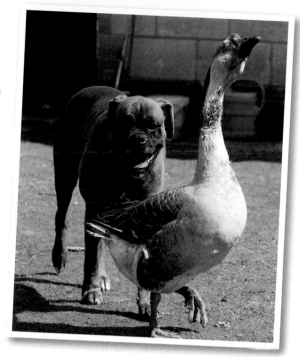

"They do bicker a lot," Renata admits. "The goose is dominant and sometimes steals Bak's food. They also play roughly together, but they are really attached to each other—in love, in a way." And they are often very affectionate, she says. When they sleep, the goose stretches out his neck across Bak's body, cuddling the best way a goose knows how. And once, when Bak was sick, Renata says the goose acted lethargic and down. "I don't think it's usual for a goose to show emotion, but he seemed to show it then."

Renata herself was recently quite ill, and she says during her recovery the relationship of Bak and Guzik brought her great joy, as did her other pets (cats, dogs, chickens). "They help me to cope, bring me solace," she says. "In Poland, in most villages, animals are treated like animals," she says. "So the way I treat them, like family, is a little strange. But I feel love for them, and I think they do for each other, too."

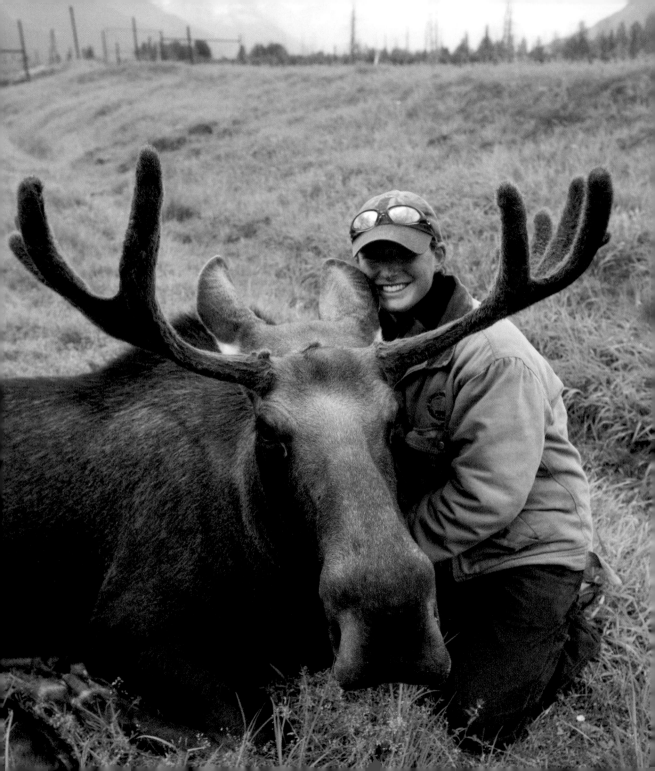

The Girl *and the* Moose

FOR ANY ANIMAL LOVERS AMONG US, INTERACTING WITH something wild, even just glimpsing a deer or drawing finches to the feeder, can send the heart skipping along happily. It's a true thrill. So imagine what happens to the heart (hint: really fast, happy skipping) when the animal you're meeting face-to-face is a moose. A *moose*! This is no supersize dog; a moose is really big, really powerful, and truly wild. The males can grow massive antlers to boot. With one wrong turn of the animal's head, an innocent bystander might get knocked flat.

But as a young creature, the moose is like many other young creatures—endearing, vulnerable, and potentially even cuddly. That's what Vanessa Gibson found out during her time as an intern

MOOSE

KINGDOM: Animalia
PHYLUM: Chordata
CLASS: Mammalia
ORDER: Artiodactyla
FAMILY: Cervidae
GENUS: *Alces*
SPECIES: *Alces alces*

at the Alaska Wildlife Conservation Center in Portage. It was there that she met, and fell in love with, Jack the Moose.

"I was a little homesick at the time," Vanessa remembers. So when her boss at the center told her that an injured moose calf had been brought to them for care, she was hopeful that a glimpse of the animal, maybe an opportunity to feed it, would ease her melancholy.

With her boss's encouragement, Vanessa ran to the center's barn and peeked around the corner. There lay a leggy little animal curled up in a pile of hay. Jack was about three days old and maybe 25 pounds. His right front leg was broken above the knee and he had a bite mark above his hip—maybe from a bear, or a dog. "He looked at me, his eyes got wide, and he cried!" Vanessa says. "And the sounds he made were heartbreaking. Moose calves make a high-pitched wail that sounds a lot like *Ma! Ma!*" Even in his sad state, "it was the cutest thing I'd ever seen . . . or heard."

The boss told Vanessa she was moose mom for the day, and she happily joined the baby in the hay with a bottle to feed him. And there she stayed. All day. All night. "After a while, Jack wouldn't relax and sleep unless he had his head somewhere on me. Someone had to bring me dinner because once I sat down with Jack I wouldn't leave."

It was to be a long haul. Jack was in rough shape, and Vanessa was worried he wouldn't make it.

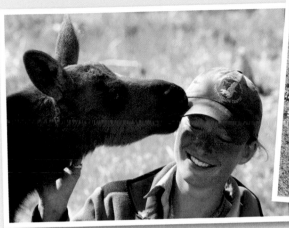

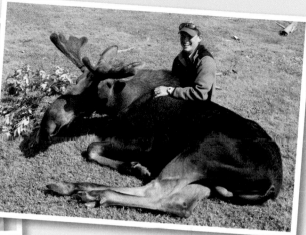

But Jack seemed to improve a bit after about a week of Vanessa's near-constant care. He even earned the nickname Captain Jack as he learned to hobble around with his leg in a homemade splint (his very own peg leg). As Jack recovered and grew through the summer, Vanessa says she didn't leave him for more than a few hours at a time. "I wanted to be there all the time. He was *my* moose at that point. I slept out in a tent so I could be near him. He got used to me being there rain or shine."

So imagine what it did to Vanessa's heart to say good-bye to Jack and return to school at summer's end. "When I was packing up my tent, he came out to see what I was doing. He put his ears back and ran away, like he knew I was leaving. I think he did know. They had to pull me from the enclosure so I wouldn't miss my plane."

She couldn't return until nine months later. That amount of time blows by at tornado speed for a college girl, but that's a lifetime for a young moose—especially in terms of its growth. Jack tripled in size during those months. That was the first surprise for Vanessa when she finally saw him again.

The second surprise was that he remembered her so well and treated her gently. "On the way there I was nervous," Vanessa says. "I'd done a lot of research on moose by then and knew that while they can bond very strongly early on, they can also, as yearlings, suddenly turn aggressive." Jack had his back to Vanessa when she pulled up to the wildlife center, and she thought, Oh! He's not going to know who I am! Or he's going to be scared or aggressive. But she was wrong, wrong, and wrong.

"When I stepped out of the car, his ears turned toward me. And before I even said anything he ran over to the fence, ears flying back, and started rubbing against my hand. He knew me immediately and was elated to see me. I was so happy!"

The two returned to some old routines. "I brushed him and he tucked his head into my shoulder and fell asleep. I lay down next to him, and he picked up his head and looked into my eyes. I tucked *my* head into *his* shoulder this time, and he then laid his head over mine. It was so special, so relaxed." Other rituals included a moose form of "fetch" (though Jack wasn't much for retrieving a stick), running around side by side, and playing chase. "I could always feel him come up behind me. I'd spin around and chase, and he'd run—he loved it."

Wild animals, even those that are raised with people, can be unpredictable—and Vanessa was aware of this each time she was with Jack. Even as a giant, however, the moose was gentle with Vanessa, never made her feel nervous or showed any sign of aggression toward her. "I knew how to act around him and when to give him space,"

she says. "So there was no reason for him to be afraid or to threaten me." In fact, if anything, Jack was overly protective of Vanessa, putting his six-foot-tall, 1,000-pound self between her and other people, other animals, even her boyfriend, staring them down. "When groups would visit and want to hear about him," she laughs, "he'd block me from them, moving up and back as I did along the fence. I'd have to sit underneath him in order to talk and be seen."

And then, the sad day came again when Vanessa had to pack up and get back to her other life. This time, Jack seemed to want to cheer Vanessa up rather than run off in a huff as he'd done before, and he made her laugh with his silly antics.

Clearly, Vanessa says, "I'm in love. And I think Jack feels something similar; he certainly has something like human emotions. There's sadness, excitement. He misses me when I leave. I'd call days later and interns would say he stopped eating, not even his favorite, bananas, after I was gone. He moped around, knowing I wasn't coming back for a while."

Still, Jack continues to thrive, Vanessa reports. "He's four now, and very healthy."

Vanessa will always know that her tender bond with the moose is what gave him the strength to overcome his difficult first weeks of life. "When I think about it, the whole thing blows my mind," she says. "I loved every minute we had together when he was growing up. It changed me." And it gave her a new career goal: moose research!

HUMAN BEING

KINGDOM: Animalia
PHYLUM: Chordata
CLASS: Mammalia
ORDER: Primates
FAMILY: Hominidae
GENUS: *Homo*
SPECIES: *Homo sapiens*

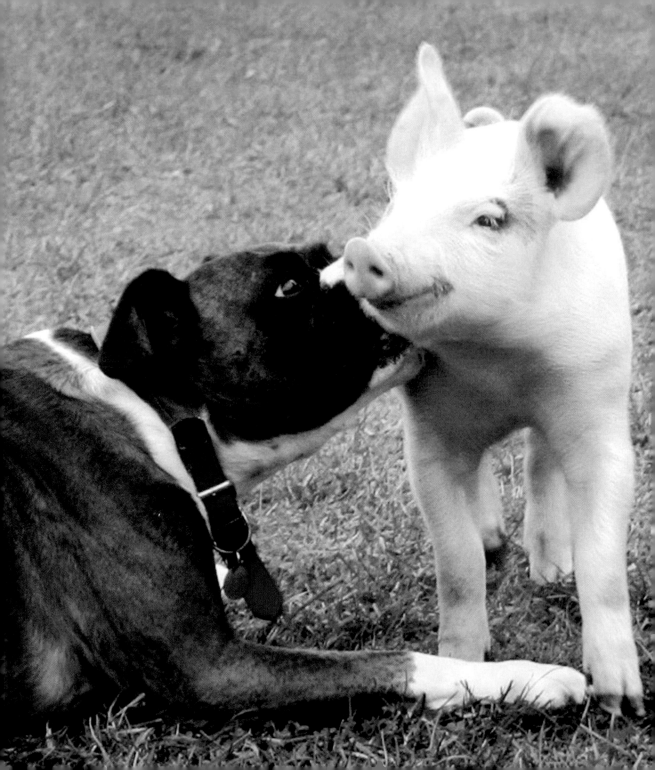

The Piglet and the Boxer

KNOWING HER HISTORY, YOU MIGHT EXPECT THAT **P**UGGY, a female boxer, would have taken one look at a young animal needing mothering and run for the hills. After all, the dog had previously lived at a Welsh puppy mill under horrible conditions—and was used as a breeder. "She basically lived in a dungeon," says her current owner, Wendy Valentine, explaining that the dog (formally named Susie) likely had multiple litters that her owners then sold. (The place was later shut down and the owner prosecuted for her crime against the animals.) So if the boxer had associated a "pup" with that kind of difficult life, no one would have blamed her.

But that's not how Puggy rolls. Instead, she gives her love freely, holding no grudge against the scent of newborn that was

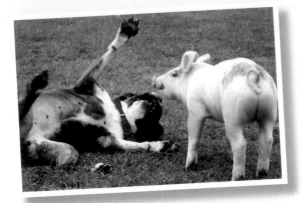

once mingled with smells of waste and filth. In fact, perhaps her old life is why she is such a generous being. She's known hardship and doesn't want any other animal to suffer.

So when a tiny piglet entered her world at the Hillside Wildlife Sanctuary in Norfolk, England, Puggy was quick to go into mother mode, as if a switch had been flipped inside her. The pig, parentless for perhaps a day or two, was an orphan no more.

Tabitha is the pig's name. She had been discovered as a wee thing alongside a road where she'd likely

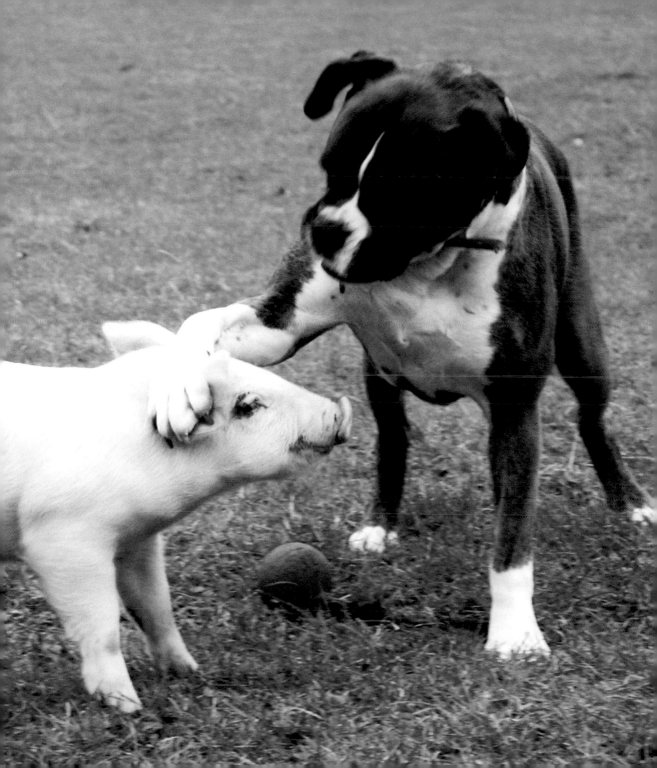

fallen from a truck bound for a processing plant. "It's possible her mother gave birth to her right there in the lorry," Wendy says, "and the baby fell through the slats." She was hardly much of anything; without a quick rescue she surely would have died.

But rescued she was, taken to Wendy at Hillside for care. Hillside is no slouch of a sanctuary. It opened on just 20 acres but has expanded to include 450 acres and houses some 2,000 animals—and the really young ones get special treatment in Wendy's warm, dry kitchen. "There are always lambs and pigs in and out of there that I'm helping along, and my dogs come and go, too, so there are many interactions," she says.

But this one was really special, she says. Puggy was immediately drawn to Tabitha, and was soon nuzzling and kissing the pig constantly. She was also very protective of Tabitha—one time biting a visitor who had smacked the pig playfully. "I couldn't believe it!" Wendy says. "I guess she was saying, *Get back! Leave my pig alone!*"

Pig and pooch would roll around in the dog bed together, or play-wrestle in the field. As the pig grew bigger, it was much like two dogs chasing and tumbling over one

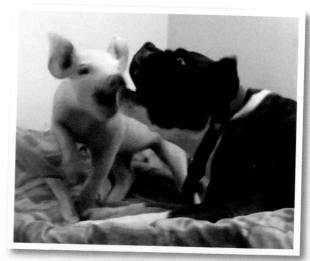

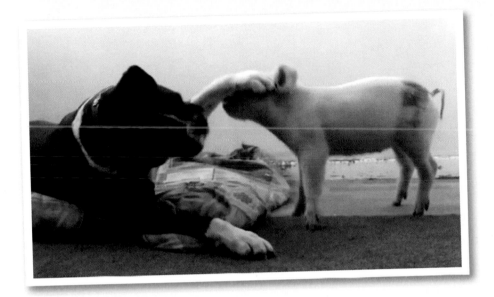

another; neither seemed to know Tabitha wasn't canine. There was truly a loving bond there, Wendy says. "I saw it whenever they were together. And if Tabitha was behind the fence in my garden and Puggy not, the dog would be nosing through the fence, licking and making little noises—I knew they just wanted to be on the same side!"

For Wendy it was fun to see the pig go from pint-size to giant, eventually surpassing her surrogate mother in all dimensions. Did Puggy realize early on that this little piggy she'd befriended would soon be an outsize beast with enough strength to put a boxer on her back? "Perhaps," Wendy says. "And maybe that's why she was so nice to her from the start."

BOXER

A common (and likely false) explanation for the boxer's name is that it comes from the dogs' tendency to "box" with their front paws when they play. But in truth a boxer boxes more with its head—swinging its muzzle hard enough to knock a cat unconscious!

♥

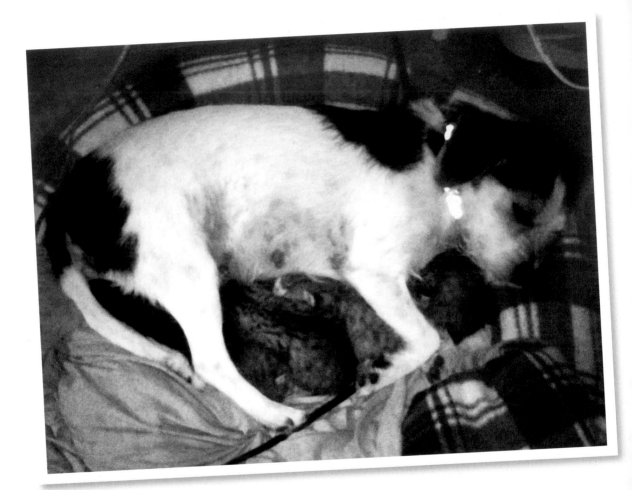

The Mama Mutt and the Kittens

MOTHERLY AFFECTION . . . IT MAY JUST BE THE MOST common interspecies love connection in the animal kingdom. And here is a particularly sweet story about a beagle–terrier mix who adopted a whole pile of kittens and became their mother not just in deed but in body and soul.

Tiny squirming felines, just a week old, needed someone to get them on their feet. Heather Rector, a young woman living in Michigan, saw a posting online that the kittens were available and required special attention—they weren't bottle-feeding very well. Soft-hearted Heather couldn't stand the idea of the cats going hungry, so she said she'd give them temporary care.

"I got them home, they were in a box on the floor in my

DOMESTIC CAT

KINGDOM: Animalia
PHYLUM: Chordata
CLASS: Mammalia
ORDER: Carnivora
FAMILY: Felidae
GENUS: Felis
SPECIES: Felis catus

kitchen," she recalls, "and within about ten minutes, my dog, Sydney, poked her head into the box, sniffed the kittens, and then began carrying them one by one by their little scruffs and dropping them in her bed." It's how she had picked up and carried her own pups when they were newborns, Heather says.

Heather thought it was a sweet behavior on Sydney's part, but it didn't solve the problem of getting the kittens to eat. She tried dripping milk off her finger, off the corner of a rag, everything she could think of, to no avail.

A day or two later, Heather planned to visit her fiancé. Sydney, she says, refused to leave the kittens, so Heather had to pack up the whole zoo and take them with her, bed and all. It was at her fiancé's house that the couple got a beautiful surprise.

"My fiancé was petting Sydney, and suddenly he noticed this white liquid all over his hands," Heather recalls. "It was milk! Sydney was lactating—making milk for these babies that weren't even hers." Sydney's last litter (of pups) had been weaned more than a year and a half before, so there was no reason for her to be producing milk anymore. But dogs can have "false pregnancies" or can lactate if the right hormones hit certain levels. It appears that the needy kittens' mewing and squirming against her had sent Sydney's brain the message that it was time to make milk again. Her motherly instinct triggered her body to be motherly, too.

Best of all, the kittens seemed perfectly happy to latch onto Sydney and drink the dog milk as if it came from their own kind—getting the sustenance they needed to fatten up.

Sydney continued to be the kittens' loving parent and protector. When Heather's other cat came near, the dog would chase it through the house to keep it away. "She's a wonderful, friendly dog—never aggressive," Heather says. "But if she thought the kittens were in danger, she showed a very protective side."

As for the kittens, they warmed right up to Sydney, following her around and climbing on her, cuddling up with her at night. When Sydney would go relieve herself outside, the kittens would follow her there, too. "We had a hard time getting them to use the litter box," Heather says, "because they wanted to go out and do what dogs do."

As the kittens began taking solid food, their dog-mom broke it into tiny pieces to make it easier to swallow. Then she'd lick her wards clean. It's like they were hers from the start, Heather says.

Heather herself was pregnant during this time, so she could understand Sydney's motherly gestures. "In motherhood, there's this unconditional love, an unbreakable bond, and I think she feels that for them," Heather says.

CATS AND DOGS

According to the Humane Society of the United States, there are currently about 78 million dogs and 86 million cats kept as pets in U.S. homes. More than a third of all households have at least one canine and another third at least one feline.

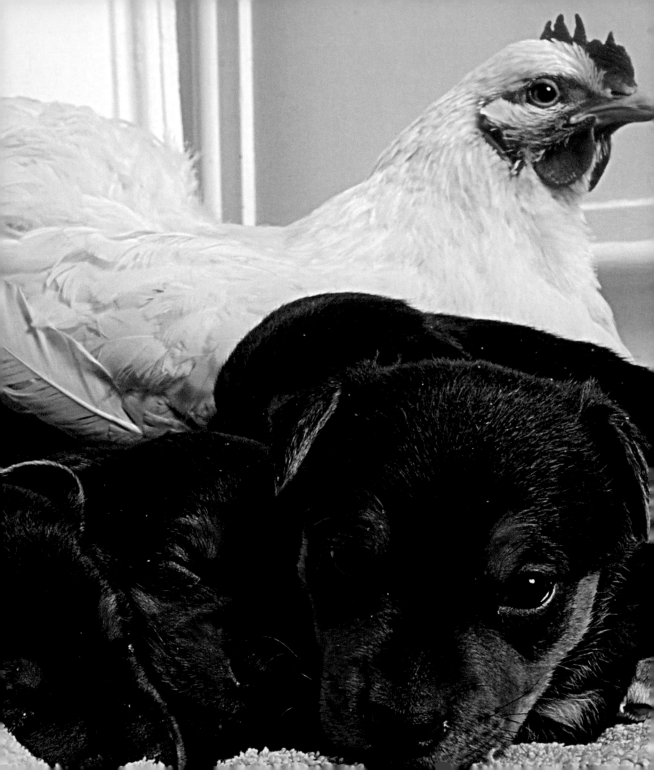

The Hen *and the* Pups

HENS. THEY SIT ON EGGS. THEY TODDLE AROUND THE yard pecking at seed. They squawk. They've got that cute little red comb like wiggly fingers sticking up from their heads. They . . . adopt puppies?

Not typically. But here's Mabel, and she's no typical hen.

She lives on a farm in Shrewshire, England, a dog-bone's throw from the Welsh border. If you exited the barn, turned left, and walked 100 miles, you'd hit London. But there's no sign of the city here: This is a peaceful spot of woods and pasture, where horses graze, doves coo, and geese visit the little lake out back. No wonder Mabel is a homebody—who wouldn't be? And though her owners build hen houses as part of their farm business, *this* hen

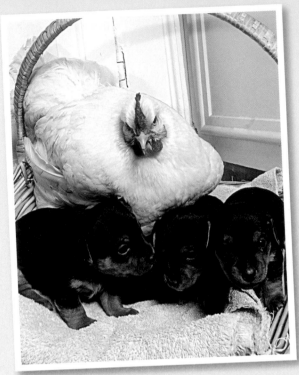

prefers a warm kitchen to any bird box, no matter how nicely made.

"We've always had chickens, love having them about," says farm owner Edward Tate. "But Mabel, the infamous Mabel, she's been quite a special bird."

It began when Mabel met the hoof of a horse. She'd been ambling about where the horses were tied up in the yard when one accidentally trod on her foot. She squawked and limped away, and soon her bum leg earned her the Tates' sympathy.

"It was a particularly cold spell, so we brought her into the kitchen to recuperate," Edward explains. (Or re*coop*erate, if you will.)

Meanwhile, Nettle, the family's black-and-tan Jack Russell terrier, had recently given birth to four lovely pups. The Tates had them in a big padded box—also in the cozy kitchen. Nettle was a good mom to her litter, but sometimes even the best parent needs time away from her little ones.

"Nettle would go out into the yard to sniff around, and that's when we saw Mabel eyeballing the puppies," Edward says. "She got nearer and nearer to the box.

CHICKEN

KINGDOM: Animalia
PHYLUM: Chordata
CLASS: Aves
ORDER: Galliformes
FAMILY: Phasianidae
GENUS: *Gallus*
SPECIES: *Gallus gallus*
SUBSPECIES: *Gallus gallus domesticus*

♥

And then one day after Nettle left, she hopped right over the side, settled down over the puppies, and spread out her wings to cover all the bits. I'm sure it was quite nice and warm on top of those little furry bodies." If a pup face poked out from underneath, Mabel would gently push it back or shift to make sure no one was left exposed.

"After a few days of this, we imagined Nettle thinking, Oh, it's that awful old hen again trying to take my place! We'd have to move Mabel out of the way—she didn't want to get up," Ed says. Meanwhile, the puppies didn't seem to care what species was sitting on them, as long as they were safe from the cold. "For them, it was like having a feathered, heated duvet," he says.

Edward's daughter Miranda recalls that Nettle was "cross at first—after all, those were her babies under there!" but she soon came to tolerate the hen. "Sometimes Mabel would wait by the box for the dog to leave, then climb in and play mom until the real mom returned." Though sure the hen was drawn to the puppy heat, "I definitely saw it as motherly affection, motherly love," Miranda says. "Mabel was at the age to have her own babies. I think she really saw the puppies as her own."

Eventually the dogs were old enough to be adopted out, and Mabel, all healed, went back to her wanderings beneath the horses— either not having learned her lesson from her previous injury or, in this case, having learned it very well. Perhaps another broken foot would get this mother hen back to her brood?

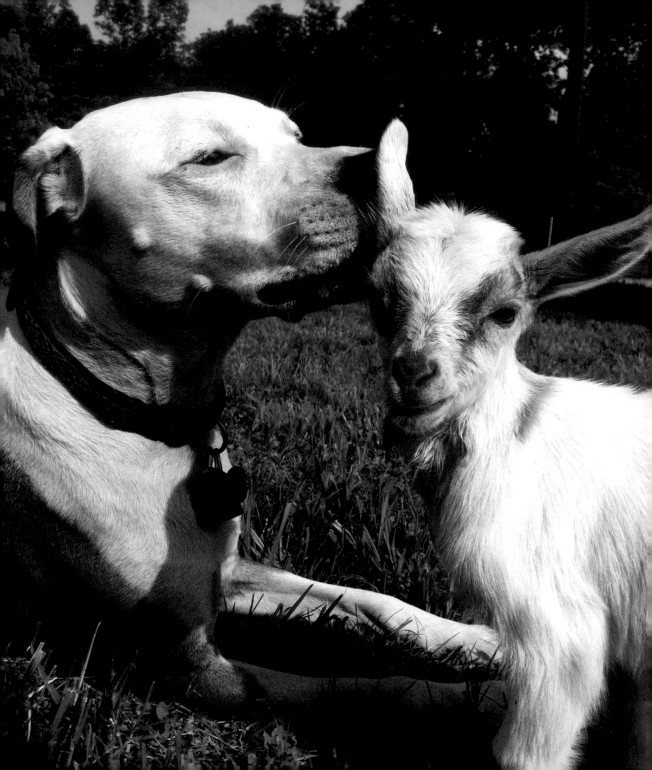

The Goat and the Pit Bull

JULIE AND NATE FREE LIVE NEAR TULSA, OKLAHOMA, on a dead end of a rural road, where horses and fishponds and barking dogs set the scene. And goats. Nate has a bunch of them. Late one April night, while away on a trip, he called his wife and asked her to please check on a certain goat that was soon to give birth. She was a first-time mama and he was worried about her.

"It was midnight," Julie recalls, "and yes, the goat was fully in labor."

"Mama delivers the first baby," Julie says, "and it isn't moving. The mom runs to the other side of the pen, not interested in him, so I scoop him up and chase after the mother because

GOAT

KINGDOM: Animalia
PHYLUM: Chordata
CLASS: Mammalia
ORDER: Artiodactyla
FAMILY: Bovidae
GENUS: *Capra*
SPECIES: *Capra aegagrus*
SUBSPECIES: *Capra aegagrus hircus*

suddenly she's having another one. And then, a third! In all my husband's years of owning goats, he's never had triplets before." When goats have three kids, as they're called, one usually doesn't make it. (Some mammals and birds have evolved to have an "extra" baby as insurance—to boost their chances of ending up with at least one healthy offspring.) Unfortunately, that seemed the likely fate for that first kid.

"I called my husband and said I didn't know if this little boy was going to make it. But of course I had to do everything I could." Julie carried the runt, still motionless, into the house and laid him on a towel on the floor so she could go get a heating pad.

Julie and Nate have five dogs, but at the time all were in their crates for the night. Except Piper. "Piper is the only well-behaved one," Julie says, laughing. She's laughing because Piper is a pit bull, and everyone expects if you have a bad dog and a pit bull, they must be one and the same. "She's just not what you'd expect," Julie says. "If the other dogs are in an argument, she'll go hide in the closet." Not exactly the ferocious monster of repute.

"So Piper is watching this whole scene. And then she starts acting very strangely," Julie says. "She's looking at the goat, then looking at me and making a very low *woof*, then looking back at the goat, back at me, the *woof*, over and over." Julie realized Piper wanted to inspect the animal, so she gave her the okay.

Piper went straight to the goat and began licking him. "She licked and licked it all over, and after a while, the goat started to come around! It's as if it suddenly came to life."

Piper and GP ("Goat Puppy") were like mother and son after the dog revived the little goat that night. Piper would clean little GP's milk-coated chin and lovingly wrap herself around him as he napped. GP would take dog walks with Piper, Julie, and Nate—a goat on a leash, "Neighbors would just stop and stare," Julie says. And when Piper was in agility training—running and climbing and leaping over obstacles—GP was right there with her, trying to follow her lead.

At one point, unfortunately, GP began dragging one of his legs. He may have gotten caught up in the fence or perhaps one of the bigger goats injured him—Julie and Nate aren't sure. At first they hoped it would heal on its own, but instead the circulation became so bad that it was clear it needed to be amputated.

"Now, I'm used to working with small-town vets," Julie says. "And they put up with a lot

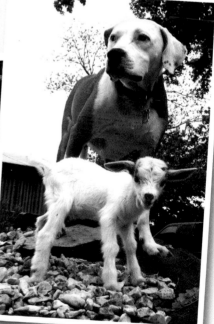

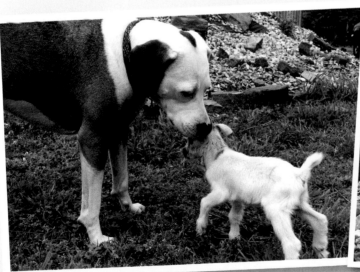

from me. But when I show up on a Sunday with a broken goat and a pit bull, saying, 'This is Piper's goat and she keeps him calm and needs to stay with him'—they might have thought I'd finally gone crazy."

Still, the vet allowed Piper in the room during the operation on GP. And at one point, Piper put her paws up on the operating table trying to see what was going on. "She was asking, What are you doing to my goat?" says Julie.

As GP recovered from surgery and began running around again, Piper continued to watch over him, play with him, and favor him over the other animals. "We have a pit bull that loves a goat, and vice versa," Julie says. "It's like nothing I've ever seen before."

Piper's love of GP, and GP's love in return, has brought a special joy into Nate and Julie's lives. "GP has a home forever here with us," Julie says. And Piper certainly isn't going anywhere. After all, she's got her goat.

GOAT

These animals have always been valuable (for milk, meat, and pelts) and popular. A couple of brushes with fame: Abraham Lincoln's sons kept two goats that lived in the White House. And Mahatma Gandhi is said to have consumed goat milk every day for more than 30 years.

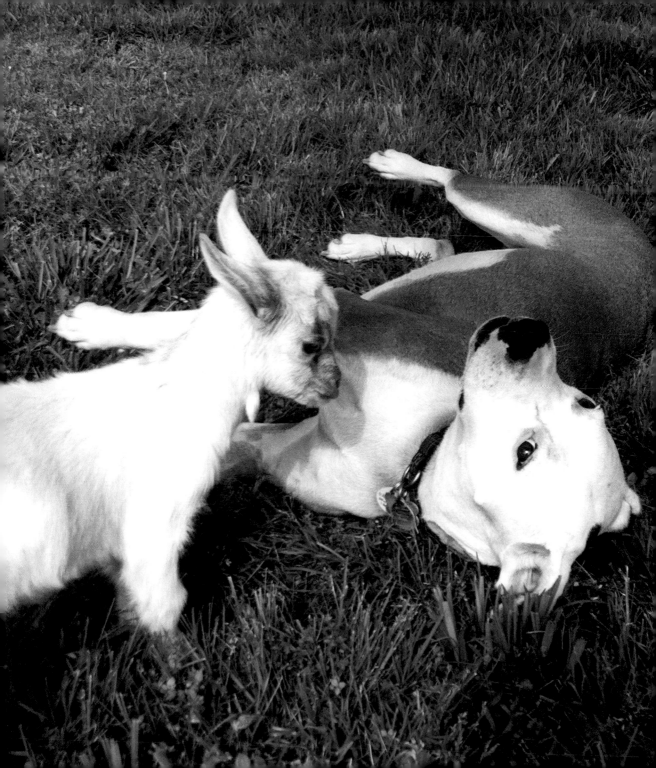

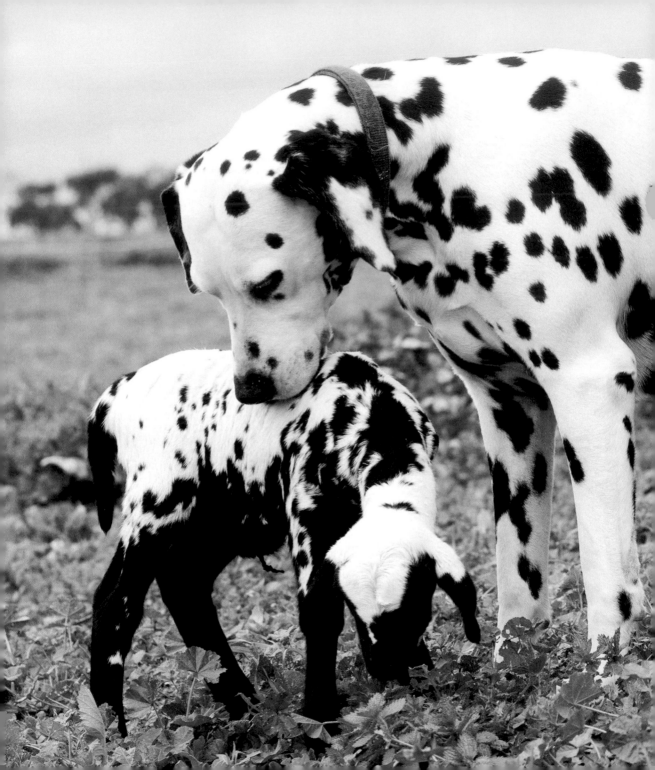

The Spotted Lamb
and the Dalmatian

FIRST OF ALL, LET'S DISPEL THE RUMORS, SHALL WE? No, a ram did not mate with a dalmatian to produce Lambie, the remarkably dalmatian-like lamb in this story. (Come on, the thought did cross your mind, didn't it?) Nature doesn't work that way. Dogs and sheep may show affection for each other, but they don't make babies together.

Still, the coincidence, call it biological serendipity, was awesome.

Julie Bolton of South Adelaide, Australia, breeds dalmatians, including seven-year-old Zoe, a gorgeous champion in the dog-show world. She's also a take-charge kind of animal, her owner says. In her own litter, "she was the first one out, and she made

eye contact with me first—she was just a little more forward than the others." That forwardness even translates to her breeding schedule; she comes into heat (is ready to mate) regularly before the other female dogs, as if to prove she's number one. She also happens to be a very good mother.

Julie and her family keep other animals besides dogs on their 32-acre Australian homestead. Sheep included. One day, one of the female sheep (called an ewe) gave birth to a tiny lamb that looked more like a spotted puppy than a sheep-to-be. The ewe took one look at the slippery runt on the ground and ran to the other side of the paddock, utterly disinterested in doing her motherly duties. (Almost certainly, the lamb's looks had nothing to do with her being abandoned; sheep focus more on smells and sounds when it comes to recognizing their young.)

Though she wasn't thrilled to have an orphan lamb on her hands, Julie couldn't help but laugh at the strangeness of the situation. "A lamb like a spotted puppy born in a home full of dalmatians," she says.

And the story gets better. With the lamb left parentless, "Zoe immediately went to it, drawn by that newborn smell. And she started to lick it, automatically doing what the mother would do." Meanwhile, the lamb-that-looked-like-a-dalmatian-puppy wanted milk and was looking for its mother. "Normally, mother sheep will make an *eeeee* sound and the baby will reply with an *eeeee*, which helps mothers know whose baby is whose in a flock," Julie explains.

But this lamb's mom made no noise; she had zero motherly know-how. So the lamb transferred its own instinctive behavior onto Zoe.

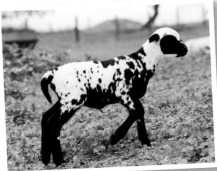

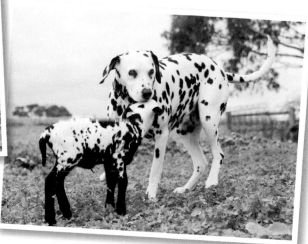

The shape and size of the animal was close enough, so Lambie went for where the udder would be, head butting, looking for a drink. Zoe, without milk at the time, turned and nuzzled it, Julie recalls. "I fed the lamb with a bottle and Zoe stayed there with me, cleaning it up. Very motherly."

Although Julie continued with the feeding duties (by bottle), the bond between the two spotted creatures was set. "It was instant love that day," and if Zoe could have fed Lambie herself, no doubt she would have. The abandoned lamb thrived only because Zoe was there to fill in for the ewe. "Lambie has never been sick, has always eaten well, has never acted depressed," Julie says. "For its health, that psychological and physical connection was so important. If you put a lamb by itself, it won't be as robust."

With time, Lambie has become more independent, eating grass out in the sunshine and doing lamb things, and even its coloration has changed to where it is less spotted than before. But when Julie takes Zoe for a walk, the lamb trots along with them, sometimes tapping its

nose to the back of Julie or Zoe's legs as it would to keep from getting separated from its mother in the tall grass. And other times it runs along full of joy, like a gazelle with all four feet coming off the ground, what Julie calls "the Lamb Olympics." Zoe and some of the other dogs will play with Lambie when the animal is in such an exuberant mood, but they are gentle with the unique baby.

As Julie reminds us, the lamb turning to Zoe when the ewe bolted was simply instinct. "Survival, you see. A baby needs to find milk. If it had seen a pig moving around," she says, "it would have bonded with the pig." A lamb needs two things, food and the flock, she says, and will seek those things in whatever animal is present. It didn't have to be Zoe.

But in this case, the little spotted lamb happened to bond with the big spotted dalmatian. And that makes this love story perfectly delightful.

DALMATIAN

According to the American Kennel Club, the dog we know as the dalmatian has played many roles over its history, including that of dog of war, draft dog, shepherd, ratter, fire-apparatus follower, firehouse mascot, bird dog, trail hound, and accomplished retriever. Most significant, it is the first and only coaching dog—guardian of the horse-drawn carriage.

♥

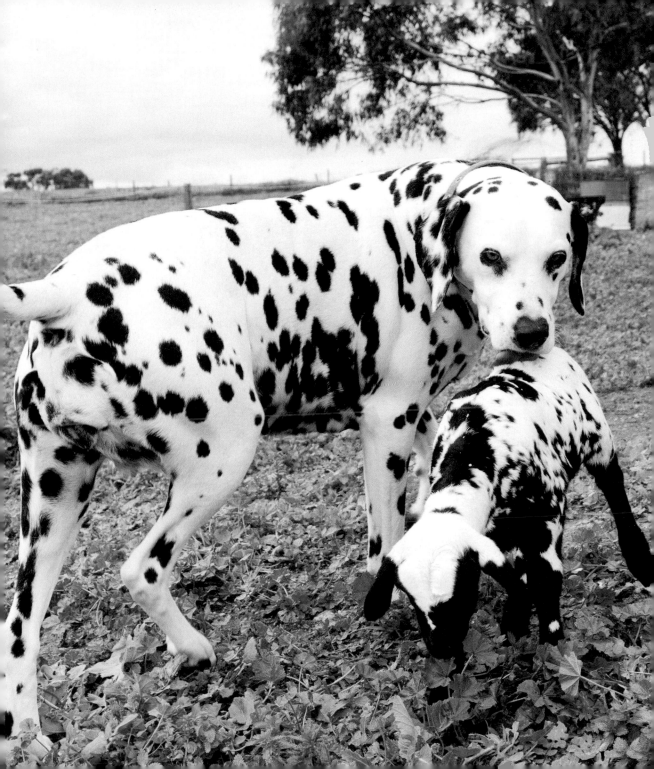

The Piglet and the Rottweiler

HERE'S A REPUTATION-BUSTING STORY THAT SHOWS that no particular breed of dog is automatically mean to the core. Sasha the rottweiler is in fact so darn sweet that by the end of this tale, you may want to adopt one or two of your own.

The recipient of Sasha's kindness was a piglet named Apple Sauce (the dad's name was Apple). Poor Apple Sauce was the littlest in the litter, unlucky number 13, and was rejected by her mother and overwhelmed by her dozen siblings. As mentioned in other stories, it is often the case in the animal world that the runt in the family doesn't make it; resources like mother's milk go to the larger, stronger animals that are more likely to thrive. "A mother might decide she doesn't want anything to do with the little one,"

explains Heidi Rhiann, at that time a pig breeder living in Llanfyllin, Powys, in Wales. "She'll send it away, won't feed it or nuzzle it, saving her attention for the others." It seems sad to us, but it makes sense to creatures that are just trying to pass on their genes as efficiently as possible.

But in this case, the piglet got a lucky break.

Heidi and her family had a small farm in the Welsh countryside where they bred a variety of animals, including micropigs, and grew fruits and vegetables. When they heard about the plight of Apple Sauce, they decided to try bringing up the piglet—of a breed called Piétrain that when fully grown wouldn't be micro by any means. And, knowledgeable about animal behavior, they had an inspired idea on how to do it successfully.

Sasha the rottweiler had just weeks before given birth to a litter of eight puppies. With her motherly hormones on full alert, she was fascinated when Heidi brought the piglet home. "Sasha was watching us work with the piglet; she kept coming over and licking and loving her while we were feeding her with a bottle. And the pig cuddled and nuzzled up to Sasha right away."

Knowing that Apple Sauce would do even better with a real mom's milk and the warmth of another furry mammal, Heidi wrapped the pig in a puppy-smelling blanket to mingle the two species' scents and put the pig in with Sasha and family. The experiment worked beautifully: Apple Sauce snuggled in with her new siblings and locked onto mom, just another hungry puppy doing what hungry puppies do. "She

truly became part of the litter," Heidi says. "Everyone treated her like a pup—Sasha mothered her like the others, turning her over, cleaning her, licking her eyes—and she took to the part. It was lovely."

The family wasn't entirely surprised. Heidi says, "She's such a lovable dog, seems not to have a nasty bone in her. She loves everyone to death, flops on her belly or jumps up when you sit down—she's an overgrown lap dog."

Now, not all stories can have a perfectly happy ending. It turns out that little Apple Sauce, despite the attentive rottie, just wasn't meant to be. "One day she was playing around, jumping and running and acting like a puppy," Heidi recalls, "and then suddenly something went wrong. We don't know exactly what—sometimes it just happens with young farm animals. We came home and she'd passed away." She points out that a mother animal that ignores a baby may instinctively know there's something truly wrong with it; this may be why Apple Sauce's mom wouldn't care for her. And that suggests that Heidi and Sasha couldn't have done anything to save the little porker from her fate.

Still, Sasha was devastated, Heidi says. "She loved and cared for that pig as if it were her own. The puppies felt the same way. You'd see them all curled up in a heap, pig mingled in with pups, no discrimination. And now one was missing." The family of humans was sad about the loss, too.

PIÉTRAIN PIG

The Piétrain breed takes its name from its village of origin, Piétrain, Belgium. These pigs express a gene that makes them extra susceptible to stress, so breeders have been working on the genetics (through crossbreeding with different pig strains) to improve their health and temperament.

"We'd been looking forward to her growing up. Piétrain pigs—the type Apple Sauce was—get really large, very broad across the rear, not like the micropigs that we breed. They're the Arnold Schwarzeneggers of pigs. It would have been interesting to see how the relationship evolved."

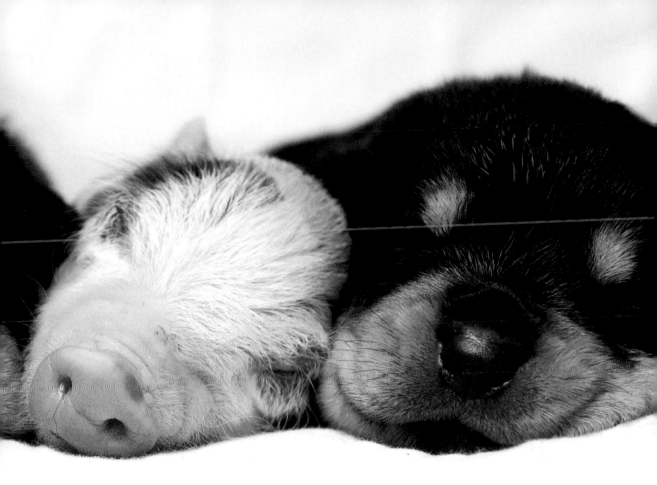

Looking back, "I have no doubt," Heidi says, "that Sasha loved Apple Sauce. She treated her as family, gave her extra weeks of life. And when people came over, she would strut around, showing off all her puppies. It just happened that one of those puppies was a pig."

Eat, Play, Love

> "Love comforteth like
> sunshine after rain."
> —*William Shakespeare*

H OW WONDERFUL THE LIFE THAT IS FILLED WITH GOOD FOOD, GREAT FUN, and sweet company. This section celebrates unlikely playmates tumbling through life together, enjoying such riches as best friends do.

In young nonhuman animals, play teaches pecking order and survival skills. So is that why these dissimilar creatures turn to each other to wrestle and chase and roll around in the grass? Maybe. But play is also fun, plain and simple. So is just hanging out together, sometimes in silence. Like human kids (and a lot of adults), other mammals seek out both fun and companionship. After all, passing the time alone can get, well, lonely.

So, please enjoy these stories of loving friendships just for the fun of them.

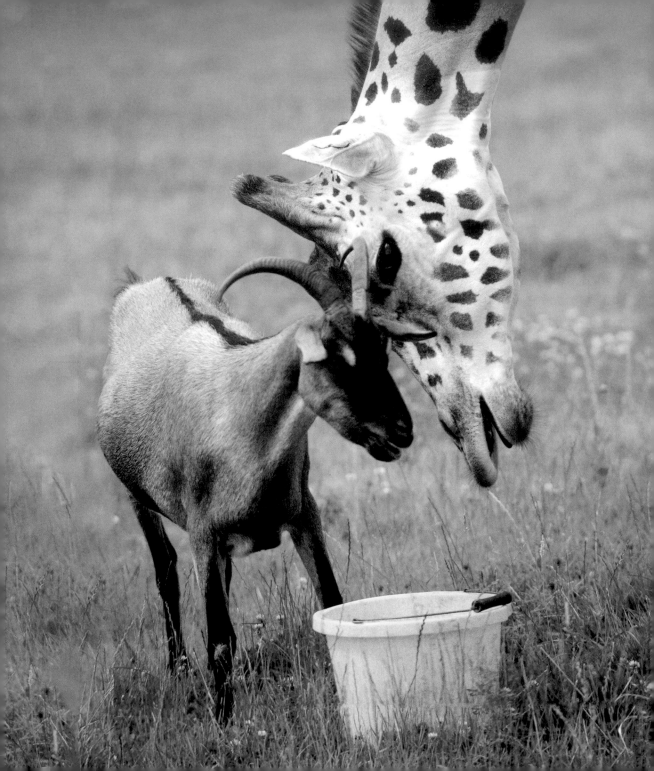

The Giraffe
and the Goat

I HAVE A LONGTIME FRIEND WHO IS **6** FEET **3** INCHES TALL. She's solid-boned and strong. To talk to her, I have to tilt my chin up 30 degrees. On my best-posture days, I can't quite reach 5 feet 2 inches, and despite all the yoga I do, my bony legs and arms appear toothpick weak. She and I didn't grow up together. To me she's always been lofty and to her I'm forever shoulder-high. When I see photos of us together, I have to smile. We appear so mismatched, yet we are the best of friends.

Gerald and Eddie make a similarly incongruous pair, and seem similarly fond of each other. His head may sit 15 feet above the ground, but Gerald the giraffe, with his roots in Africa, looks down on Eddie the goat, a local English bloke, with nothing but respect.

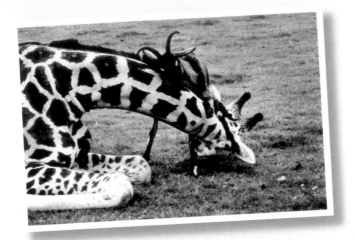

The two animals live at Noah's Ark Zoo in Bristol, England, where they came together to ease Gerald's loneliness while he waited for a mate. This love story begins in 2006, when Gerald arrived at the Ark. At first the giraffe was nervous and tentative. Then he met Eddie.

Eddie is a gregarious and pushy goat, born right at Noah's Ark. Proving that opposites do indeed attract, the social little goat and the trembling tower of giraffe became smitten with each other. Just being around Eddie seemed to make Gerald more comfortable with

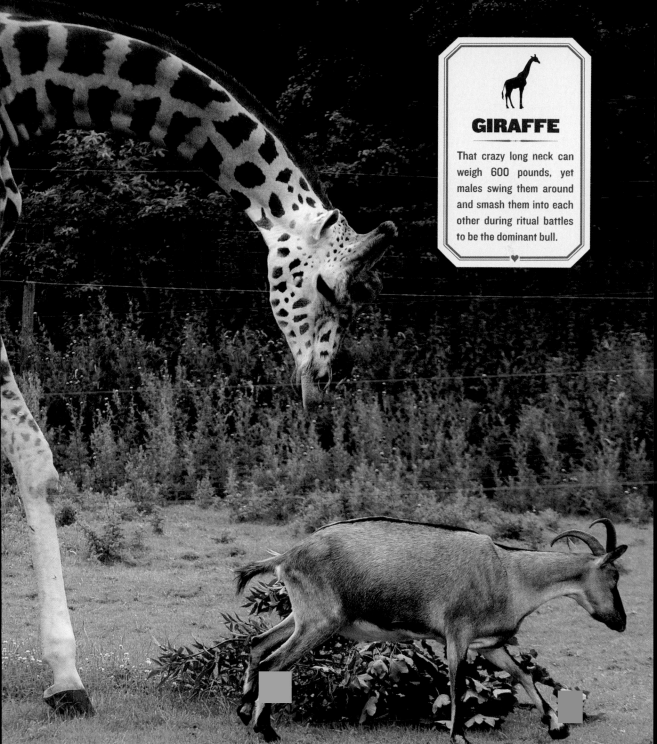

GIRAFFE

That crazy long neck can weigh 600 pounds, yet males swing them around and smash them into each other during ritual battles to be the dominant bull.

GIRAFFE

KINGDOM: Animalia
PHYLUM: Chordata
CLASS: Mammalia
ORDER: Artiodactyla
FAMILY: Giraffidae
GENUS: *Giraffa*
SPECIES: *Giraffa camelopardalis*

his new surroundings. It was like they'd known each other from the start.

Predictably, "Eddie was in charge of the pair," says zookeeper Sammi Luxa. Eddie would lead, and Gerald would follow. They'd stand side by side and eat together, then Gerald would lean down to the goat's eye level so they could rub their faces together. "Once Eddie even tried to jump on Gerald's neck," Sammi says. "They were truly like loving brothers." Despite many traits suggesting otherwise, "I think Gerald might have thought he was a goat!"

When it came time for Gerald to meet a lady giraffe, Eddie was like a best buddy, the perfect wingman. Genevieve arrived and Gerald seemed unsure how to behave with his own kind. "He was too much for her," Sammi says, of the suddenly overbearing male. But the goat—as if responsible for this new, more confident Gerald—stepped in to help. "He was like a relationship counselor, helping to get them together. Eddie was very friendly with Genevieve, and slowly Gerald followed the goat's lead." Once the giraffe showed interest in the new girl, the staff moved Eddie to be with other goats, particularly a billy goat called Hercules that needed a pal. He also buddied up with a newly arrived male camel—"Eddie is a friend to all," Sammi says.

Best of all, "Gerald was for the first time interested in another giraffe; it was like he finally grew up." That interest turned to something more, and Gerald and Genny now have a baby called George who lives with his parents in the Giraffe House. Though no longer in touch, Eddie

might be happy to know that he is partly to thank for the happy family's success.

Meanwhile, could there be a new interspecies adoration in the making? Perhaps. "Baby George the giraffe just loves our new baby zebra Zag, born just a few months after him," Sammi says. Apparently, like father, like son.

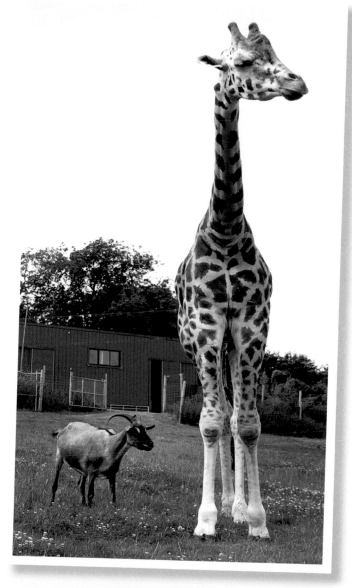

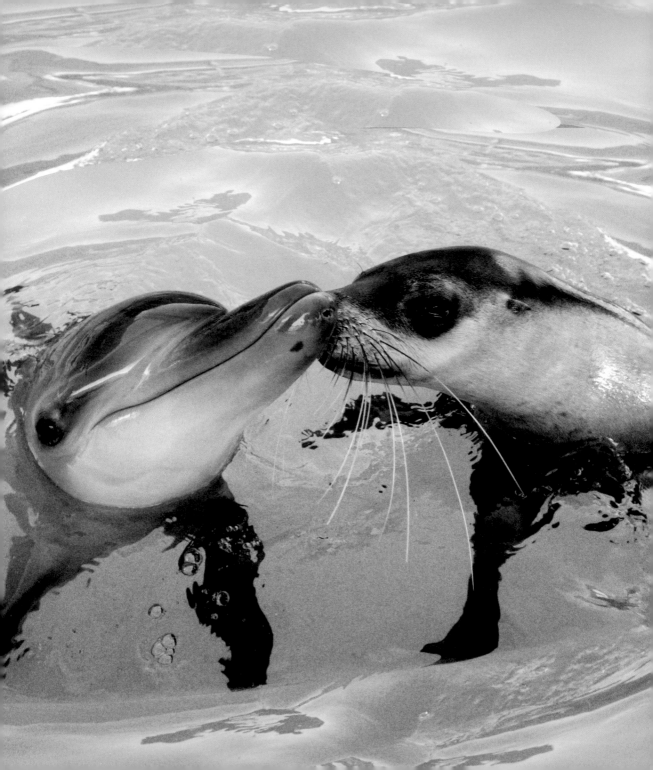

The Dolphin and the Sea Lion

WHEN DOLPHINS PLAY, THEY PLAY WITH ALL THEIR BEING. Have you ever seen them, either at a zoo, marine park, or, if you've been very fortunate, in the wild? They leap. They fly. They tease one another. They pass things back and forth. They chirp and click and squeal. If you listen really hard, you'll swear they're laughing.

I once had the honor of playing with a wild dolphin off the coast of Ireland. I'd heard about the friendly animal from locals; she'd often show up when boats were anchored in a certain area, curious about humans in her element. The boat captain knew just where to go, and I pulled on my scuba gear as we motored to the spot. The sea was cold and choppy, but I jumped right in, sank to the bottom, and waited. Hopeful.

Within a few minutes, I sensed a live presence nearby. And then a beautiful dolphin flew past me. She was so fast I was caught off guard; she then turned and zipped back the other way, nearly grazing my shoulder. I think she enjoyed surprising me with each pass.

When the dolphin came back a third time, she had a long strip of sea grass across her beak, which she let fall at my flippered feet. I picked it up and swam around with it for a bit, then "tossed" it away. She took it up again, circled, then again let it sink. I think we were playing dolphin fetch. And in an unforgettable moment, I found that if I turned upside down and dug around in the sand with my hands, she copied my posture and poked the sand with her nose, tail up. Being a dolphin's playmate was a true thrill.

Okay, I know this story isn't called "The Dolphin and the Writer," but I wanted to share my happy memory because it came to mind as I researched an unlikely duo from the sea. At a marine park in Australia,

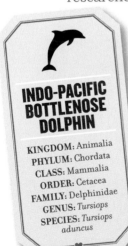

INDO-PACIFIC BOTTLENOSE DOLPHIN

KINGDOM: Animalia
PHYLUM: Chordata
CLASS: Mammalia
ORDER: Cetacea
FAMILY: Delphinidae
GENUS: Tursiops
SPECIES: Tursiops aduncus

♥

there's a sea lion–dolphin pair of pals that play together like two little kids. They swim together and toss toys back and forth (given sea grass, they might just play fetch!); the dolphin chirps and the sea lion barks in response. There's an exuberance that builds between the pair that sets them apart from the rest of the animals. Together, they are joyful and light, the way I felt around the dolphin in Ireland.

The dolphin, a bottlenose, is Jet; the Australian sea lion, Miri. They were both born at Coffs Harbour Pet Porpoise Pool in New South Wales, the largest marine

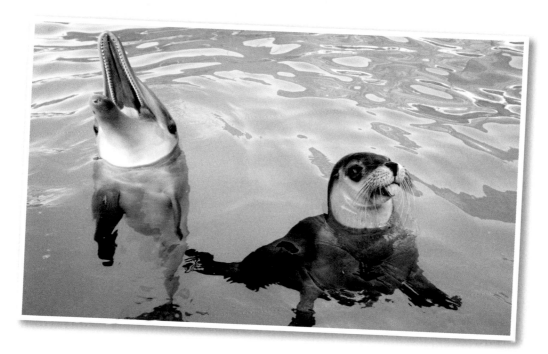

mammal facility in Australia, which opened in 1970 as an animal rescue and rehabilitation center. Now interactive entertainment is a large part of the park's mission, and Jet and Miri are a big part of the show. According to park staff Aaron Tolley and Paige Sinclair, during "free time" when the park's various marine animals have the freedom to play together in each other's pools, they noticed cute interactions between Jet and Miri. The trainers decided to capitalize on the animals' special relationship, enhancing it by training them to perform together. "In the wild, sea lions and dolphins would be competitors for food, certainly not friends," says Paige. But they were so at ease with each other.

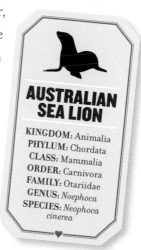

AUSTRALIAN SEA LION

KINGDOM: Animalia
PHYLUM: Chordata
CLASS: Mammalia
ORDER: Carnivora
FAMILY: Otariidae
GENUS: *Noephoca*
SPECIES: *Neophoca cinerea*

"They're happy side by side," says Aaron. "Sometimes if Jet takes too long eating his fish, Miri will come grab it by the tail and pull part of it out of his mouth. Most animals probably wouldn't put up with that, but Jet lets her; he shares it with her."

"In play drive, they're well matched," says Paige. "Both are young and inquisitive, both love toys—though they have different favorites. Miri likes chew ropes and Jet likes monkeying around with basketballs and footballs." Jet whistles and Miri, when she's in the mood, coughs up a reply. Though they obviously speak different languages, they don't seem to see each other as different. "They're as comfortable together as if they were the same species," she says. "We don't see that kind of ease among the other animals."

One affectionate encounter between Jet and Miri was clearly a favorite. During practice for a show, the trainer gave the command for the two animals to slide out on stage together on their bellies, landing front and center, side by side. "They both followed directions and came sliding out," Aaron recalls, "but then Miri rushed over to Jet and started kissing him on the nose. It wasn't set up, it just happened. It was quite sweet and funny."

"They seem to really trust each other, to know neither will hurt the other," Paige says. "There's a special bond that you just wouldn't see if they hadn't grown up here, with the freedom to play and get to know animals unlike themselves."

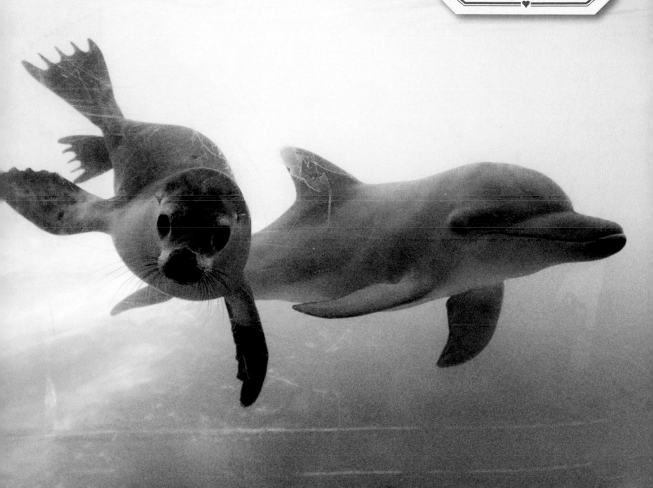

DOLPHIN

Dolphins heal remarkably quickly and fully from shark bites and other wounds. Scientists hope we can learn something from the animals' powerful immune systems.

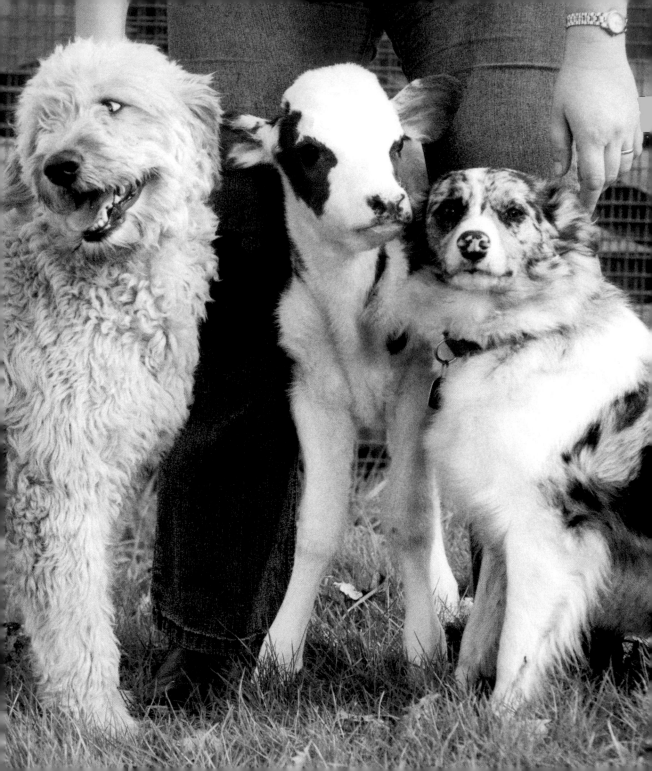

The Tiny Calf and the Farm Dogs

CLEMENTINE WAS BORN TOO SOON. IT WAS TEN DAYS before her due date and she was half the weight she needed to be when she left the warmth of her mother's womb to face the wintry earth on Locksbeam Farm in Devon, England.

But this tiny calf was lucky. Though her mother was unhealthy and had no milk to give, her human owner, Tracey Martin, wasn't about to let her die. It was a cold, cold winter, so Clementine, as Tracey called her, got to live inside.

"It's a farmhouse kitchen, with a big cast-iron stove that radiates good, constant heat," Tracey says. "That's what Clementine needed. She seemed to have no muscle at all; she was a bag of bones. We knew she was underdeveloped and would require intensive care if we were going to save her."

COW

KINGDOM: Animalia
PHYLUM: Chordata
CLASS: Mammalia
ORDER: Artiodactyla
FAMILY: Bovidae
GENUS: Bos
SPECIES: Bos primigenius

That care included not just the hot stove but the biggest dog bed Tracey could get—one that easily held both her collie and her retriever–poodle mix. Once Clementine entered the kitchen, the dog bed became an interspecies napping ground. Tracey tucked towels around the baby cow, just 23 inches to the shoulder, and since there was plenty of room to spare, the dogs attempted to join her. It was a little crowded for a trio, but at any time at least one dog was nestled in next to the baby. "When Bess, the collie, was in there, she'd lick the calf—it was so fun to watch. Or if Bess was in the bed and Clementine got in after, she'd be so careful where she put her feet—she was so considerate, not wanting to step on the dog."

Clementine had her outdoor fun, too. "Mostly she slept like a child at first. She was so tiny, like a premature baby. But then she started going out with the dogs. She'd hop, skip, and jump around on the lawn, and the dogs would follow her, infected by her mood." Instinctively the collie would try to round up the calf, bounding along next to her, as if it were the dog's job to keep her in line. And one afternoon, Tracey says, the dogs went off to play with Tracey's four kids, who were visiting their grandparents across the road. "Clementine was out on the lawn, and I guess she heard them on the other side of the road and was not happy to have been left behind. She squeezed through a hole in a hedge and crossed over to join them. She was very determined to be part of the pack."

It was that determination, no doubt, plus the companionship with other animals, that got Clementine through those early weeks when she was still underdeveloped. "She truly had the will to survive," Tracey says.

The calf became a bit of a local celebrity, for her size and stubbornness, and for her partnership with the pups. "I don't think Clementine thought in terms of calves, dogs, and people. We were just social beings like she was, the only ones she knew." She and the dogs were in and out together all the time, lying down together, chasing each other around, and going nose to nose. Interestingly, when Clementine was eventually introduced to other calves, "she was confused by them," Tracey recalls. "Really didn't know what to make of them, their smells and sounds. She was much more comfortable with the dogs than with her own kind."

At a year old, Clementine now lives on another part of the Martin's farm, independent of her dog family. But even without canine encouragement, her determination to thrive continues, says Tracey, and she just keeps on growing. Darling Clementine is miniature no more.

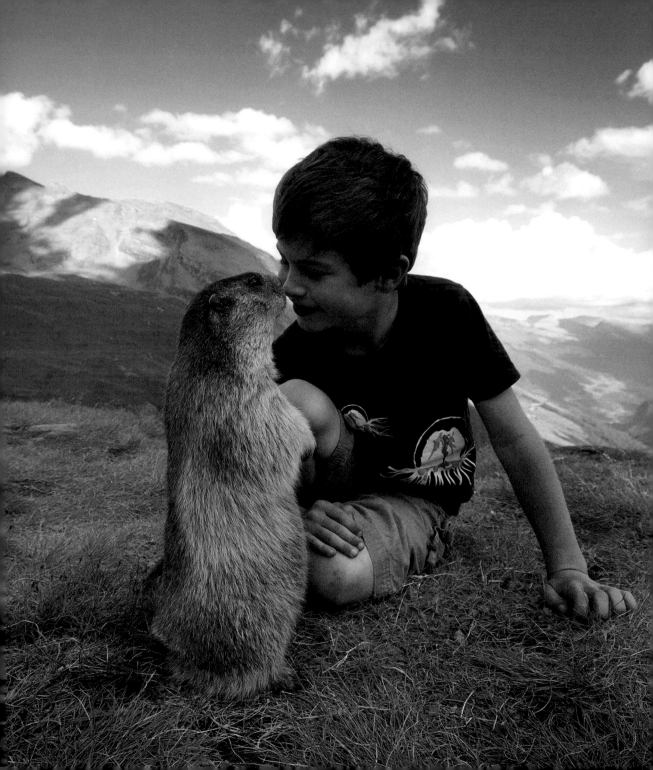

The Boy and the Marmots

I REMEMBER WELL MY FIRST SPECIAL ENCOUNTER WITH A wild animal. It was just a squirrel in my neighborhood, nothing exotic or dangerous, but still the interaction had a big effect on me. I was probably seven years old, and I spent a lot of time exploring outdoors, trying to get close to birds and squirrels without scaring them off, poking at bugs and caterpillars, digging up worms with sticks. Living things fascinated me.

So one afternoon when a pudgy brown squirrel began eyeing me from its perch halfway up a tree trunk, I eyed it back. I clucked my tongue at it, moved a little closer, and clucked again. Most of the time that sound will get a squirrel's attention, but if you get too close it'll dart away. This one stayed put, seeming intrigued. Then

ALPINE MARMOT

KINGDOM: Animalia
PHYLUM: Chordata
CLASS: Mammalia
ORDER: Rodentia
FAMILY: Sciuridae
GENUS: *Marmota*
SPECIES: *Marmota marmota*

it came down the tree. I continued my squirrel sounds, and the next thing I knew, the squirrel was heading toward me across the grass. I stood still. It approached cautiously, in fits and starts, closer and closer, and suddenly it was right there. Sitting *on my foot* looking up at me! This squirrel liked me! It wanted to be near me! It was on my foot! I managed to crouch down halfway, slowly, and touch it on its soft little head. It let me. Finally, it scampered off.

I called him (or her) Scurry, and for some weeks after, when I went outside and made my clicking sounds, that same animal came around to greet me. I didn't actually try to pick it up—like all kids, I'd been told time and again that wild animals may bite and can carry diseases. But having it near me of its own accord was thrilling. Eventually it stopped showing up. But I felt special that it had chosen me as its human friend, at least for a time.

That's the feeling that a young boy named Matteo has for a group of animals he's befriended in Austria. He met them in a park called the Kaiser-Franz-Josefs-Höhe at Grossglockner, the highest peak in the country. It's a territory known for marmots, large mountain-loving ground squirrels (a bit more exotic than Scurry was), and the population there has become rather accustomed to people. However, no one has gotten to know and love them like Matteo Walch has.

Matteo's mother, Michaela, likes photographing wildlife and wanted to visit the park, more than 100 miles from their home in

Innsbruck, to get some good pictures of the marmots. Her son, then just three years old, wanted to go, too.

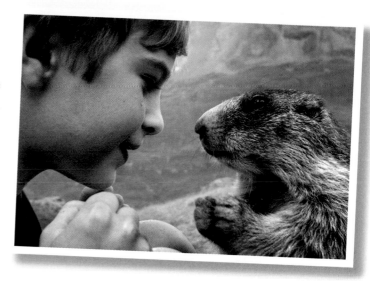

"When we arrived, we didn't see many around," she recalls. "But then we tossed a few carrots and that did the trick. Marmots were everywhere! Pretty soon Matteo was running around with them and they were coming right up to him. One of them actually ran into him, knocking him down. He was just loving it."

"At first, I was a little unsure," Matteo, now nine, told me (in German, translated here) about that first encounter, "because their claws were sharp and scratched my leg. But then I touched them and their fur was so soft! And they're so cute and good-natured."

Most of the time, kids who visit the park enjoy seeing the marmots for a bit, but then they get bored and want to do something else. Not Matteo. "Once the marmots became friendly, he didn't want to go home," says his mom. "We spent the whole day with them, until dark. It was freezing cold, but he didn't want to leave them. And the next day he said, 'Back to the marmots, please!' So we returned and spent another whole day among the animals. He really loved playing with them. They built up a special friendship."

And so visiting the marmots became an annual activity for Matteo and Michaela, and each time they came, the animals responded to the boy as if he were an old friend. "When I first sit down they come storming at me," he says, "wanting to see what's in my lunchbox. But I think it isn't just the food they like. I think they recognize me. They're happy to see me; they jump with their front paws in the air."

Matteo has named some of the animals—Felix (the smallest, sweetest one) is his favorite. "Sometimes," he says, "he asks me to go nose to nose. He comes close and nods his head twice, so I lean down and we put our noses together." Other times "they all just go wild, climbing all over me. Every day, there is something different."

During their stays at the park, he says he wakes up excited. "Yay, I get to see the marmots today!" He's sure they are always waiting for him, wondering, "Where did you go? What took you so long to come back?" While out in the meadow with them, "I don't think about anything else, not even playing Legos." And when it's time to go, he says some of the animals follow him for a bit, like they don't want him to leave. "I'm sad when I have to go home, especially at the end of vacation when I know I won't see them for a whole year."

His reciprocal friendship with the marmots has taught Matteo a lot about animals—how to treat them, and how to show his love for them. "I'm glad," his mom says. "I'm glad he's learning about wildlife and getting to know the beauty of nature. That's so important."

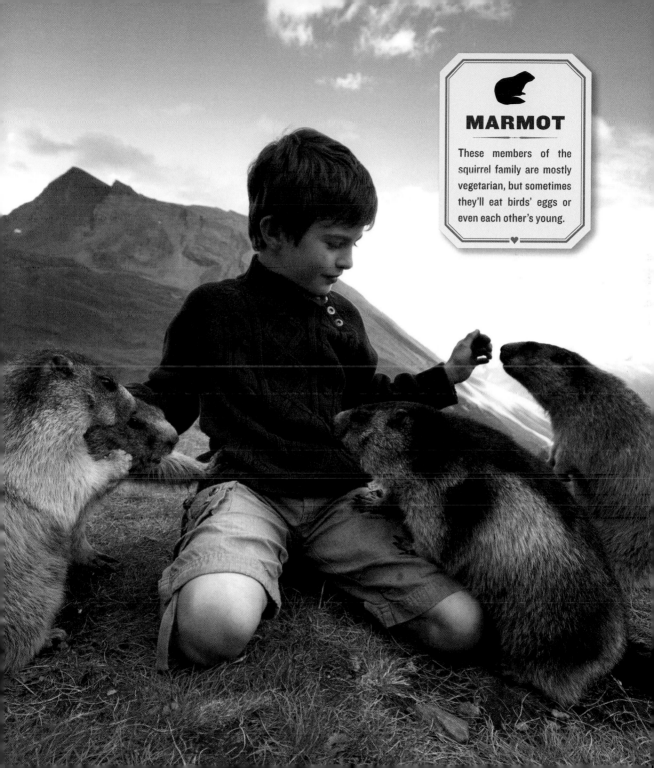

MARMOT

These members of the squirrel family are mostly vegetarian, but sometimes they'll eat birds' eggs or even each other's young.

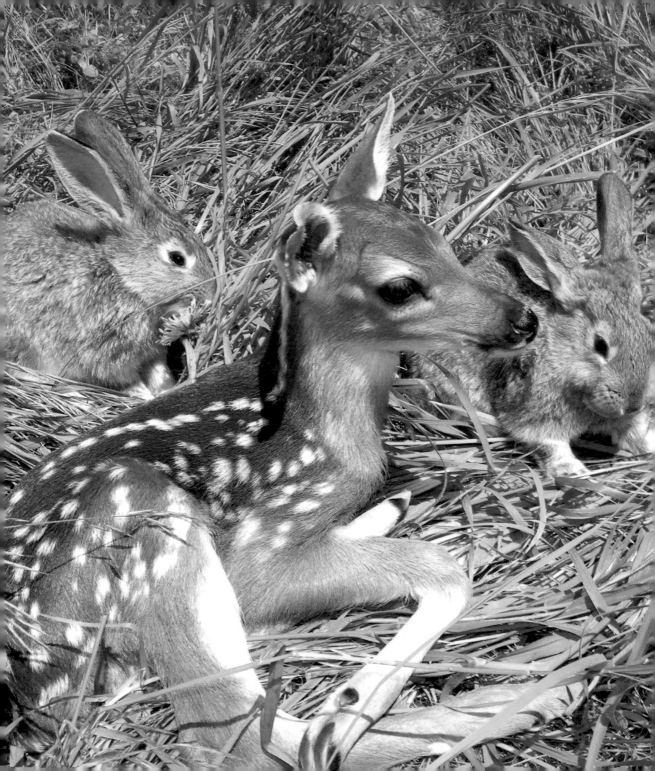

The Fawn *and the* Woodland Friends

I**T DOESN'T MATTER WHERE YOU COME FROM; THE STORY** of Bambi seems to be part of all of us. Can't you picture that candy-colored, tranquil scene of the smiling fawn surrounded by all kinds of woodland creatures? Maybe you recall the squirrels, raccoons, and skunks, the rabbits on a log, the wise owl perched in the tree above? Or perhaps the possum family hanging by their tails all in a row, tiny birds with beaks full of flowers, and butterflies fluttering here and there—the sprinkles on an already sweet cake. The scene truly looks to be spun of sugar.

Of course, we can't forget that the story started out taking a tragic turn, with Bambi's mother shot by hunters. But the orphan fawn finds he can rely on his woodland friends. So there is, as you'd expect, a happy ending.

WHITE-TAILED DEER

KINGDOM: Animalia
PHYLUM: Chordata
CLASS: Mammalia
ORDER: Artiodactyla
FAMILY: Cervidae
GENUS: Odocoileus
SPECIES: Odocoileus
virginianus

That tale, down to the Bambi-Thumper friendship (and maybe even the Bambi-Faline love affair), has played out at the farm home of Svetlana and her family in a small town in Montana. There, a motherless fawn found himself embraced by unfamiliar animals as he recovered from the trauma of his loss and, later, made his way back into the wild.

Svetlana has always loved animals, and as a child growing up in a village in Ukraine she longed to have more of them around. "I always dreamed of living in wild country," she says, and happily, when she came to the United States, she fell in love with a man who could fulfill that dream with her. Sharing his 18 acres in rural Montana, myriad wild things, from elk and bear to cougar, moose, and deer, were right there on the family property. "It made my life so happy," she says. "Even though the deer would eat all my plants, my life was fuller having them around."

So what happened next seems fated. Late one summer night, driving through a rainstorm with terrible visibility, Svetlana suddenly came upon something in the middle of the road—a small, wet animal frozen in her headlight beams. She hit her brakes.

"He didn't move, just stood staring at me," Svetlana says of the tiny fawn. She got out to help, and noticed some blood on the ground. "His mother had been hit and killed; she was in the ditch next to the road. I wrapped the baby in my coat—he was completely soaked. He

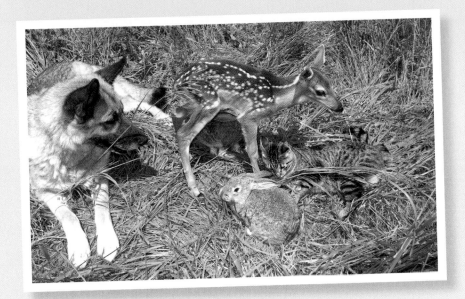

didn't make a sound, just let me pick him up and put him in the car." There was a truck coming, she says. "If I'd left him there he would have ended up like his mama."

Svetlana took the fawn home and warmed him up, and the family named him Bambi. At that point they had two German shepherds, and one of them, an older female, was immediately taken with the fawn, following him around and licking him. "He was in shock at first, and wouldn't eat," Svetlana says, but with help from her motherly dog, soon the fawn was slurping down his meals.

When the bad weather passed about a week later, Svetlana put Bambi outside with all her other animals, and that's when friendships formed much like those in the children's story. "The rabbits

REX RABBIT

KINGDOM: Animalia
PHYLUM: Chordata
CLASS: Mammalia
ORDER: Lagomorpha
FAMILY: Leporidae
GENUS: *Oryctolagus*
SPECIES: *Oryctolagus cuniculus*

would poke their noses into him, and he'd nose them back," she says. "They cuddled together and he'd follow them as they hopped around—pulling on their tails. The rabbits would munch on dandelions, and he would sniff and try to eat them, too. Then the rabbits would steal the flowers from his mouth!" The rabbits and deer seemed content to hang out together in the barn, getting to know each other, she says.

Bambi was also partial to Svetlana's other pets. The cat would groom the deer; the dogs would play tag, chasing, touching, and running away, and Bambi would turn around and do the same in reply. "Everyone loved playing with the baby deer. My kids, too!"

Svetlana wanted to make sure the deer would be able to return to the wild if he chose to, so after a couple of weeks she and the kids reduced their contact with him. "We watched to make sure he was safe, but didn't touch. He found his own games: flinging chunks of tree bark around and stomping on them, even throwing aluminum cans into the air and jumping up after them."

Soon other wild deer started coming around, and Svetlana was pleased to see Bambi's curiosity piqued. He slowly began socializing with them, spending more time among his own kind and less with Svetlana's menagerie. (She held her animals back more and more, to let the transition happen.) He went into the woods with the other deer, coming back now and then to his "family," but eventually, his visits became infrequent and then stopped all together. "We cried when he stopped coming, but it was beautiful to see him relate to other deer," says Svetlana. "That was the hope all along."

The experience reminds Svetlana of a time when she was a child back in Ukraine and her grandfather nursed an injured raven back to health. "He built him a cage, fed and took care of him," she recalls. "And when the bird was ready, we let him go. Like seeing Bambi return to the woods, it was nice to see him fly away free."

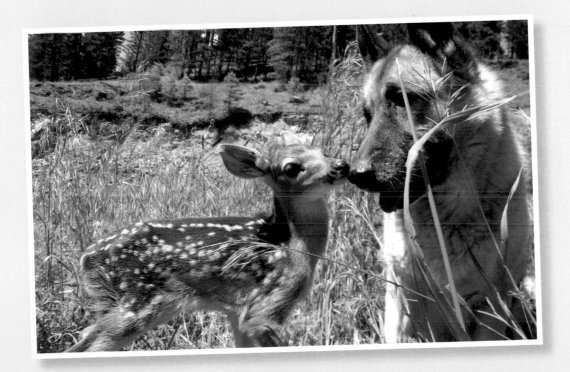

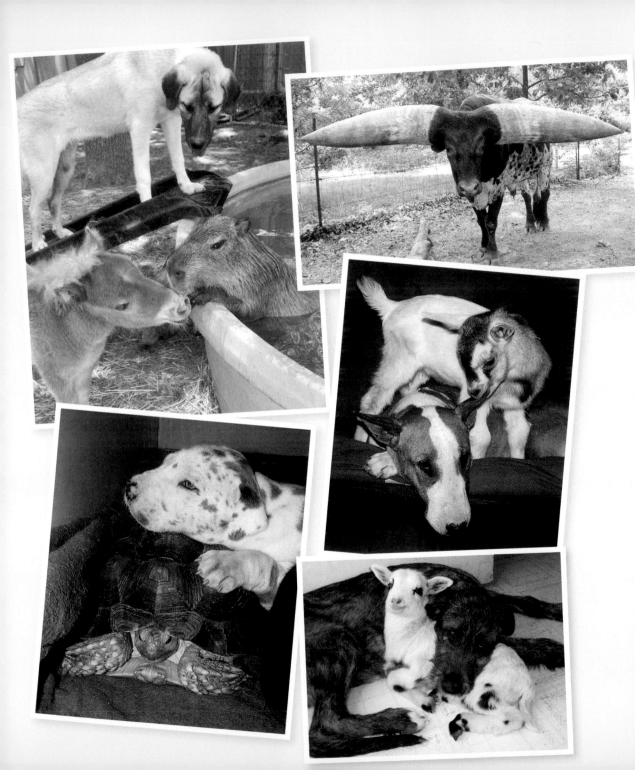

Tales from
Rocky Ridge Refuge

KINDNESS AND LOVE ARE WAYS OF LIFE AT THE ROCKY Ridge Refuge in Arkansas, where more than sixty animals at a time find a haven from the rough world outside. Janice Wolf is their caretaker. And, with absolute commitment, she spends her days immersed in a furry, slobbery, smelly world—feeding, cleaning, petting, and loving each and every creature in her care.

But she's not the only one spreading love to those around her.

She's had a zebra that served as protector of her sheep. A goose that left the world of geese for a canine's love, and a pregnant deer that did the same thing—actually seeking out her dog friend when it was time to give birth. There was a blind dog that didn't have to see to take care of every little thing that crossed his path.

A rabbit that spent its days tucked in bed with an injured pup that couldn't romp and play with the others. And so on.

Clearly I could write a whole book on the relationships at Rocky Ridge. Instead, I picked three to highlight. One is a case of a persistent little gal who refuses to leave her beloved(s). The second is a tale of mutual affection that includes some poolside flirting. The third is a story of paternal love from a totally unexpected beast. All three stories are based on commitments that many married people can't claim.

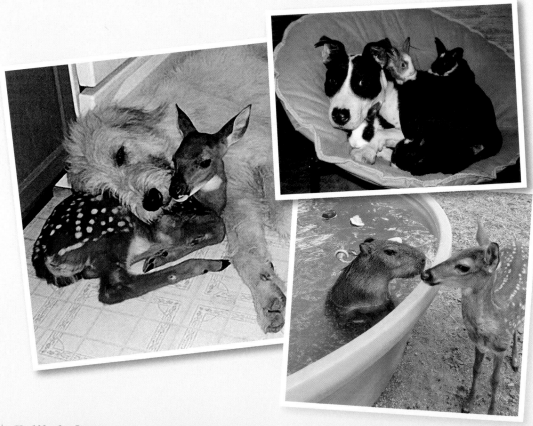

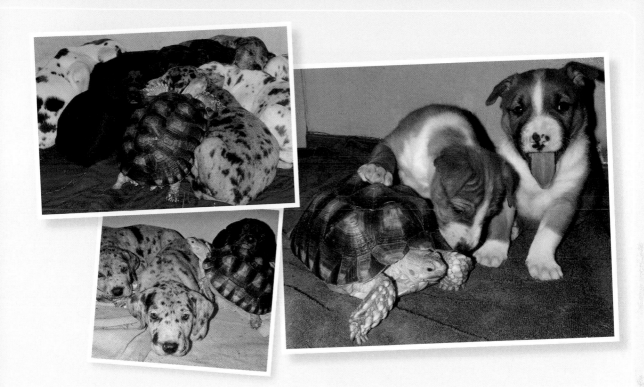

The Tortoise *and the* Puppies

WE'LL START WITH **CROUTON** BECAUSE, WHY NOT? **CROUTON** is an African spurred tortoise, after all, and what's better than an affectionate reptile named after a crunchy salad bit? When she came to Rocky Ridge, "she was shy and slow; she'd been neglected and wasn't very sociable," recalls Wolf. Reptiles need lots of warmth (usually just the physical kind), so she was given her own little heating blanket, and she spent a lot of her time under or atop it. But then came the Great Dane puppies. Ten of them.

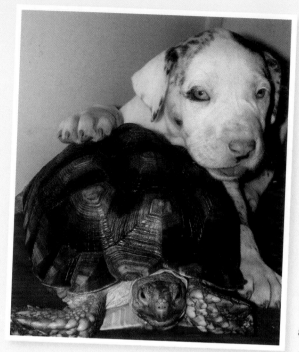

They were born to a rescue dog Wolf had taken in. The mother gave birth in the bedroom, and Wolf moved the whole squirming litter into the bathroom, where they'd be safe and out of the way. That's when Crouton took notice. "She started abandoning her blanket and going into the bathroom to join the pile of puppies," Wolf says. And not just join as in sit around the bathroom with them, but crawl in among them, literally bury herself in puppies. "She'd deliberately get in the middle of them, even when they got rowdy. She could go anywhere she wanted, and had her own warm place, but she chose to be with the dogs as much as possible. She would make a beeline for them every day as they wrestled and knocked each other around. She really loved those animals."

At feeding time, Crouton remained part of the pack, Wolf says. "I'd call *puppy puppy puppy!* And they'd all come running. And here's this tortoise among them, running faster than some of the dogs, trying to get her head into the pan of mush right alongside the others! It would just crack me up."

AFRICAN SPURRED TORTOISE

KINGDOM: Animalia
PHYLUM: Chordata
CLASS: Reptilia
ORDER: Testudines
FAMILY: Testudinidae
GENUS: *Geochelone*
SPECIES: *Geochelone sulcata*

Crouton took a special liking to a particular Dane, and though Wolf had planned to adopt out all the animals, she decided to keep "Crouton's pup," named Guppy. "I didn't want to interrupt Crouton's love story," Wolf says. "They'd lie with each other, actually cuddled up. The dog would even use Crouton as a pillow." (Doesn't sound like the most comfortable choice, but who can argue with love?)

And though nowadays Crouton spends a lot of time in a sunny spot in one yard with Guppy elsewhere on the property doing doggie things, whenever the tortoise is apart from her love for too long, "she'll haul butt right back to him. She's full of personality and affection for her pup." And that's saying a lot for a tortoise.

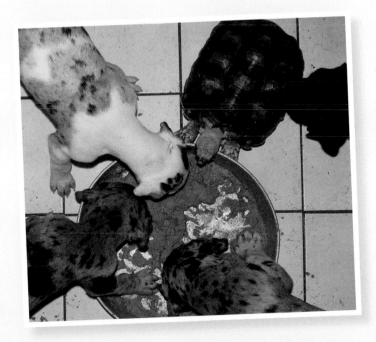

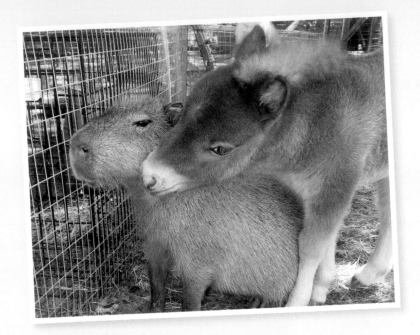

The Miniature Horse and the Capybara

NOW, A QUICK NOD TO A PAIR THAT, WELL, JUST REALLY liked each other. There wasn't a long courtship leading up to their affectionate alliance, but Janice says it was special nonetheless. How could it not be when the characters are the world's biggest rodent (called a capybara) and the least-big (truly miniature) horse?

Janice had rescued two pregnant miniature horses, and one of them, Tofu, gave birth inside the pen of Cheesecake, a capybara. (Capybaras, for those unfamiliar with these supersize rodents, are a

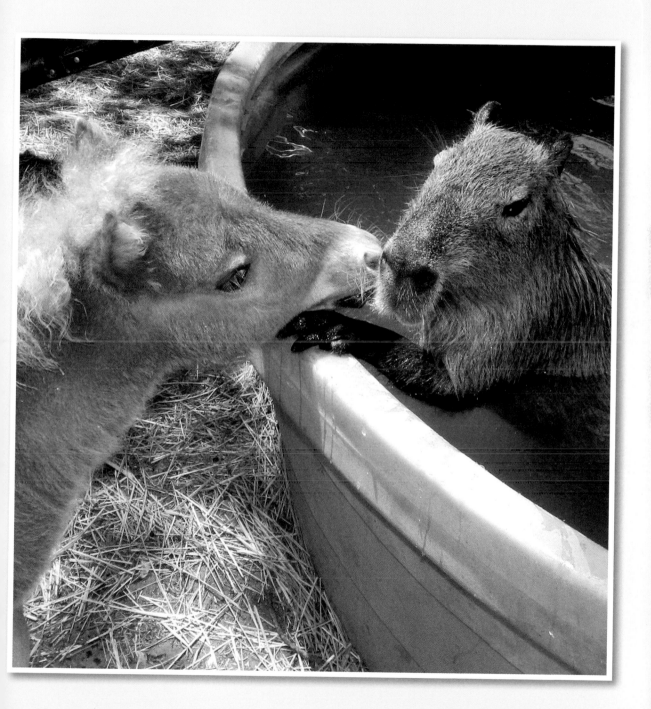

South American animal that's comfy both on land and in water.) At first, one of Janice's dogs, Butterbean, "just wouldn't leave the foal alone. She was all over him." But after a few days the dog lost interest, and Cheesecake saw an opening for her affection. "They would run around the pen together and eat and sleep together. They really had fun," she says. And then came afternoons by the water.

"Cheesecake loved to swim, and it seemed she liked it best when Tofu was with her," says Janice. The capybara had a little pool, and she'd splash around while Tofu stood by the side, head hanging down, watching her. "He really seemed to want to get in there, but he was too big," Janice says. So Cheesecake would swim over and give him a little nuzzle and a kiss. "They were best buds. I've since put Tofu in with a zebra that needed company, and another foal lives with Cheesecake. But I know Cheesecake and Tofu will always have a particularly strong attachment to each other."

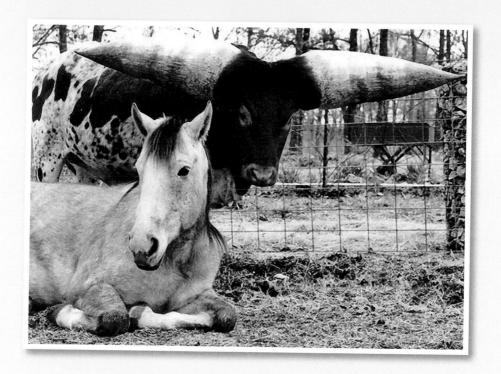

The Bull and the Horse

FINALLY, ENTER THE ANKOLE-WATUSI BULL, LURCH. FIRST off, could there be a better name for a bull? This imposing animal with the perfectly suitable name was, in a sense, father to all around him. "The benevolent leader," says Wolf. "He nurtured all the animals and they followed him everywhere. Miniature cows ran after him. A chicken used to sit on his horns. A goose fell in love with him and would eat, sleep, and swim with him. Everyone loved Lurch."

And Lurch loved everyone back. But maybe he loved a certain horse just a little bit extra.

Lurch was of an impressive ancient breed of cattle, but that wasn't the full explanation for his charisma. Even as just a wee calf, he had a special *something* about him.

Special indeed. Lurch's horns, which continued to grow even when his body settled down, would ultimately land him a spot in the Guinness World Records for their amazing circumference of 37½ inches (they eventually reached 38 inches or more). The length of the horns was also nothing to sneeze at: They reached at least 8 feet tip to tip!

But before his horns made him famous, Lurch became well known for that sweet temperament toward other animals, and toward one in particular. "When he was young," Janice recalls, "I rescued a crippled horse. Once I got him walking a bit and able to live in the big field with the rest of his kind, the other horses would crowd him out of the food troughs and leave him behind when they ran off to play."

Lurch observed the lone soul being pushed around and seemed distressed. "From then on he appointed himself Chance's bodyguard," says Janice. "He stayed near him and slept with him, and when the other horses pushed Chance away from the food, Lurch even shared his own food pan, something he never did with any others. They had such a tight bond."

She says Lurch seemed to be particularly careful around Chance as if understanding that the horse was vulnerable. "When Lurch had a

fly on him or an itch, he could really fling that head around to scratch it, and those horns were dangerous! But around Chance he never did that." Also, "he let Chance use one of his horns to scratch itchy places the horse couldn't reach, even standing perfectly still so Chance could rub his eyelid on the tip!" Apparently, the bull understood that his headgear had the power to injure as well as to aide.

The horse trusted him completely, Janice says, just as the rest of the animals did.

Sadly, Lurch passed away in 2010. Ironically, perhaps, it was cancer in one of his mighty horns that killed him—when it caused blood vessels to rupture.

Janice says she can't think of Lurch without remembering the remarkable faith and kindness he brought out of the creatures with which he shared the world. "I think that's the kind of love we're all looking for."

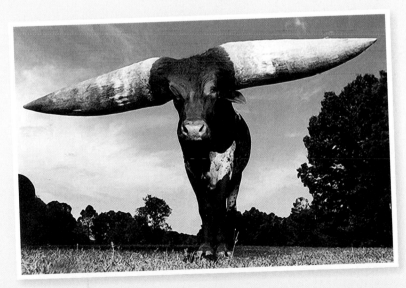

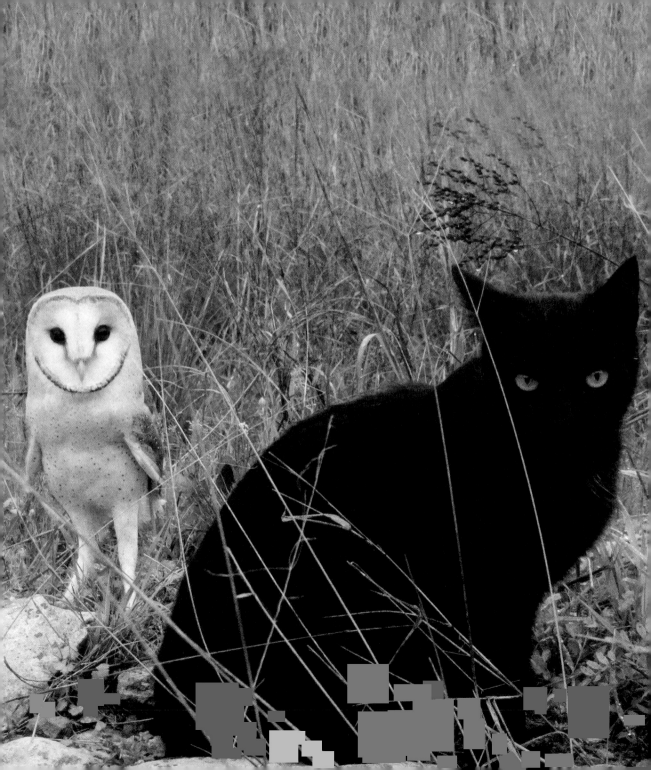

The Owl and the Pussycat

ONE RAINY DAY, I WAS BROWSING THE INTERNET IN search of cute and funny things, and I came across a video that blew me away. The characters: a slender black cat and a striking barn owl, face white as snow. The moment caught on film: the cat's amazing jump from the ground straight up to meet the owl in the air. Now, felines are naturally good jumpers, but this cat clearly had springs in its paws, letting it reach new heights, to high-five a bird swooping well overhead.

The owner of these acrobats is Jordi Amenós, of Tarragona, a city located near the Mediterranean Sea in the south of Catalonia on Spain's northeast coast. Here's what he told me.

Fum was the only black cat in the litter; his three brothers (and also his mom) were bone white. Adopted by Jordi, the cat was

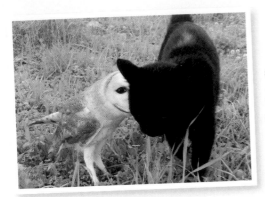

soon living the good life in the great outdoors. Fum, his "stage name," means "smoke" in Catalan. His name is appropriate; like smoke, occasionally he disappears!

And then there's Gebra, a barn owl. In Catalan, the bird's name means "frost," in lovely contrast to Fum. The owl was young and came without any feathers (as owlets do), so for a while, she stayed inside with Jordi and he fed her by hand. As Gebra's feathers grew and she started using her wings, the two animals began to notice each other. When Jordi, who practices falconry, began training Gebra outdoors, the bird was tethered and he kept the two apart to avoid them becoming entangled. But once Gebra was ready to fly freely, cat and owl were allowed to meet on their own terms.

"That first jump by Fum—leaping up to the flying bird—had quite a big impact on me because I thought it was the end of Gebra," Jordi recalls. "I didn't know what Fum's intentions were." Jordi recalls crying out, *"Mare de Déu! Aqui prendrem mal?"* which from Catalan he translates to, "Oh, my God, will there be an injury?"

Fortunately, there wasn't. And fortunately for all of us who love this story, Jordi soon realized he couldn't stop the animals from their antics, so it was better to just let them develop their game. "Soon it was no longer a circus spectacle, but something deeper," he says.

Whatever that depth between owl and bird, their acrobatics, which quickly became part of their normal outdoor routine, are certainly a

spectacle! As Gebra flies down from a tree and soars like a big-winged jet parallel with the earth, Fum leaps into the sky with his front paws overhead, as if to smack down a moth, and his timing is perfect for reaching the lowest point of the bird's mighty swoop. It's as exhilarating to watch as any trapeze artist flying through the air, reaching for that swinging bar.

Fum and Gebra find other ways to entertain themselves when the flying games are done. The natural surroundings on the farm in Tarragona are like an amusement park for a feline and a bird. The nearly 2 acres are a mix of tall grasses, carob and olive trees, a big fig tree with plenty of perches for owl and cat alike, rock walls and boulders, dirt paths and open skies. Jordi's videos show the pair chasing and leaping on each other both on the ground and up in the trees, the cat batting, the bird nipping, both returning again and again for more.

"Their relationship was completely spontaneous and has grown on its own," says Jordi. "Seeing them moves something in people's hearts." He says he feels so fortunate to be the main witness to this unique connection.

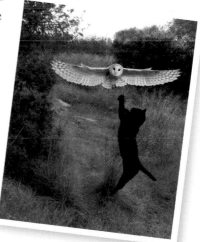

"What's most important, though, is their lesson of how to have a better, kinder world," Jordi says. "Here are animals, different in many ways, and there is no prejudice, no hatred. Hopefully their message can endure."

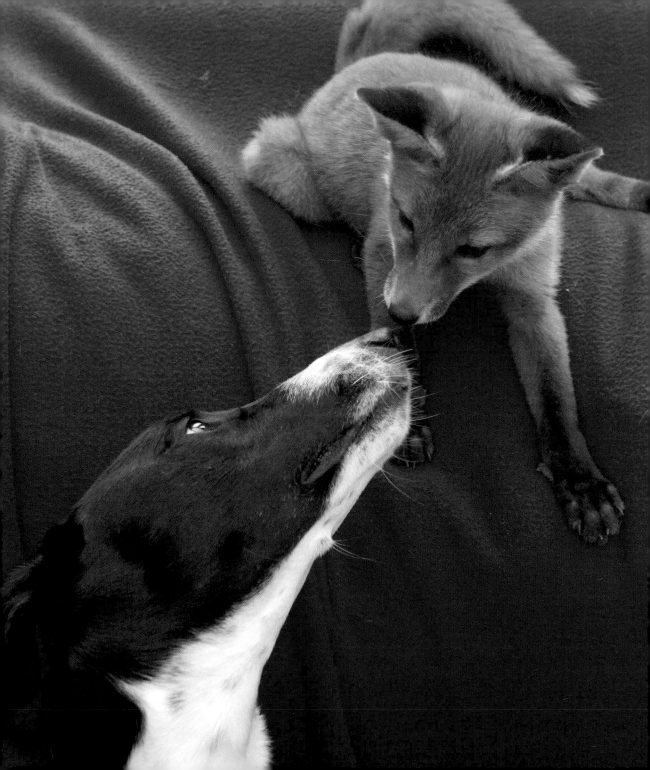

The Fox
and the Hound

TRUTH SOMETIMES MIRRORS FICTION, AND IN THIS CASE the real thing comes awfully close to the animated story. Disney's version of *The Fox and the Hound* was plenty sweet: Though instinct and social pressure to be adversaries pull childhood friends apart, their loving bond is never truly broken. Now meet Copper and Jack, the living, breathing fairy tale.

Copper is a male fox that, like many animals in these stories, got off to a rough start. He was an orphan—on his own in a grassy field for at least a few days after birth. And then, somehow he managed to fall into a rocky pit in the back garden of a rural home. Luckily, a tangle of ivy caught him as he fell, preventing what might have been a deadly landing. Fortune shined on him again when his

squealing cries met the garden owners' ears. Not knowing how to handle the little animal, they called on animal expert Gary Zammit to come rescue him.

Gary runs the Feadon Wildlife Center in Cornwall, England, an 80-acre patchwork of grasslands, woodlands, and ponds. Visitors come to get up close to the wild roe deer, badgers, reindeer, hedgehogs, owls, hawks, and, of course, foxes.

"When I rescued Copper, he was probably a week or two old," Gary says. "But he still needed bottle feeding 'round the clock. He was dehydrated and in poor condition—hadn't had food for days. We don't know what happened to Mom or the rest of the litter, and this guy wouldn't have survived much longer on his own."

Copper was quite vocal, which stirred the interest of another animal at the center, Jack the dog.

Jack is a lurcher, a hound mix whose breed originated in Ireland and England. Like Copper, he had a sad beginning—his at the hands of an unfeeling owner. Soon after birth, the owner scooped up the entire litter and took them to the vet to be put to sleep because she thought they were ugly! Of course, the vet refused to kill the pups and instead found homes for them.

"I hadn't planned to have another dog, but after getting to know Jack, we had to have him," Gary says. "He's so lovely and affectionate, walks around among the chickens, goats, and ducks without chasing them. He has no hunting instinct at all. A wonderful animal."

But Jack had never really mixed with foxes before (there were two others at the facility when Copper came). Even though he wasn't an aggressive sort, Gary says, "Most dogs would attack and kill a fox, so we never thought to put them together. Copper at that point would have fit nicely into Jack's mouth, so we had to be cautious." But Jack kept coming around to see what the fuss was about. His interest was piqued by the squealing cub and he wasn't going to back down. Gary finally decided to let the dog inspect the new arrival.

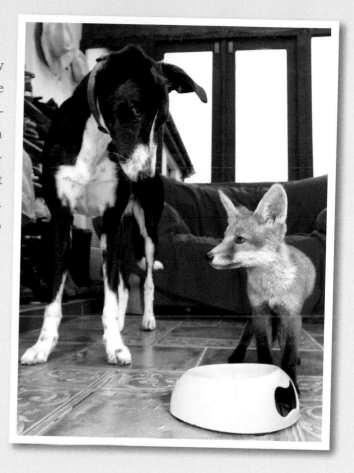

"There were no signs of aggression, just a wagging tail and other friendly gestures," he says. "The fox cub, meanwhile, latched onto Jack right away. He was submissive, rolling over to show his belly, squealing and squeaking. After that he wanted to be with Jack all the time." So fox and hound became napping buddies, spooning for hours at a time, with plenty of reciprocal muzzle licking. And they love to play together:

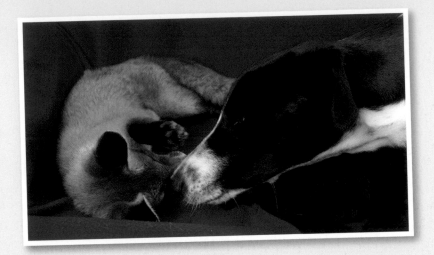

The two charge around the house and wrestle until fully exhausted, and somehow Jack knows to be gentle. If things get a little rough, a tiny yelp from Copper settles the dog right down. Jack wears a bell around his neck, and Gary says Copper quickly associated the sound with his new friend. "When he hears it, he wags his tail and calls, searching around for the dog, wanting to play. They're totally devoted to each other, even though Copper now has other foxes in his life."

This time, truth is even sweeter than fiction.

RED FOX

That beautiful fluffy tail performs many tasks: It gives the fox better balance, serves as a warm blanket on cold nights, and is used like a signal flag in fox-to-fox communication.

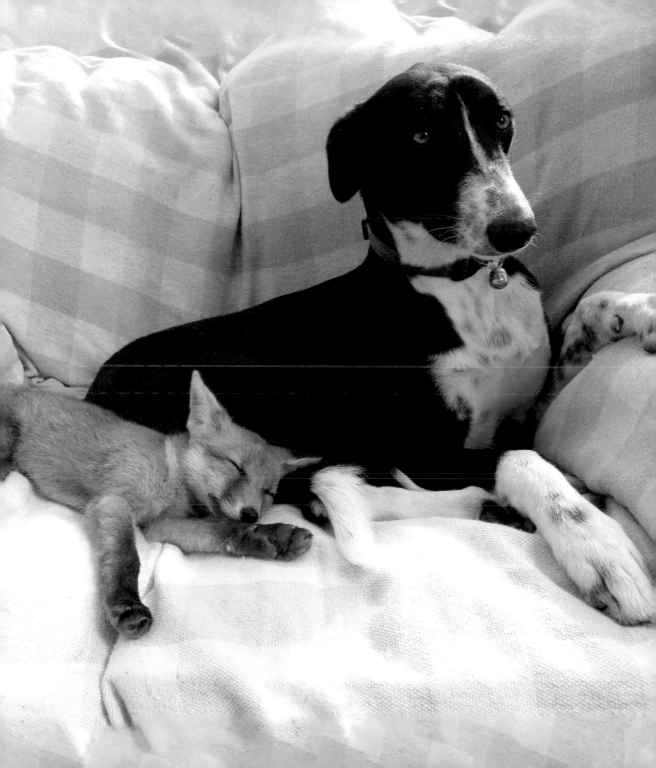

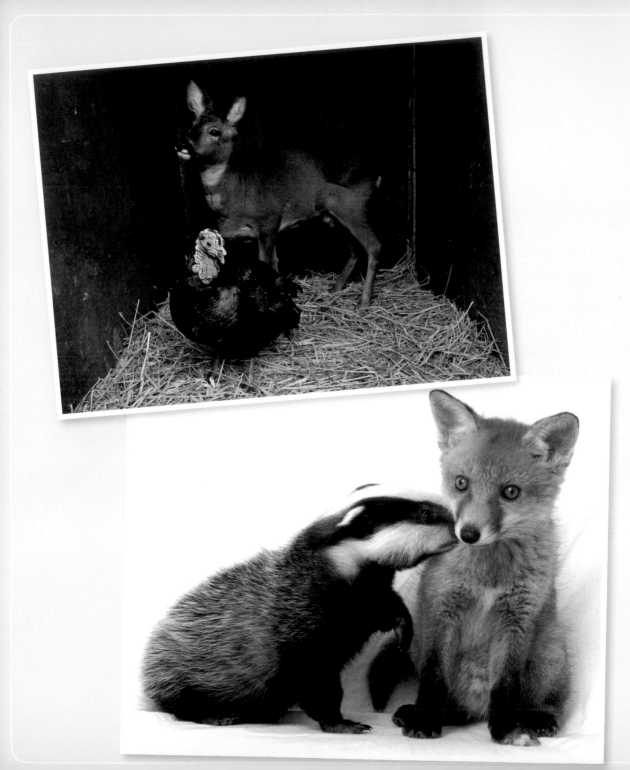

Tales from
Warwickshire
Wildlife Sanctuary

GEOFF GREWCOCK NEEDED A CAREER CHANGE. AS AN armored truck driver, he'd been injured during a robbery, and the trauma got him thinking: Was there something more meaningful he could do with his life? Something to improve the lives of others? Happily for the stray and wounded creatures of Warwickshire in England, in 2001 Geoff opened the Warwickshire Wildlife Sanctuary, to care for both wild and domestic animals in need. Even those left on his doorstep during the night—everything from pet spiders to foxes and deer—are welcomed inside, and into his heart. The place changed his life. It also became the setting for our next two unlikely love stories.

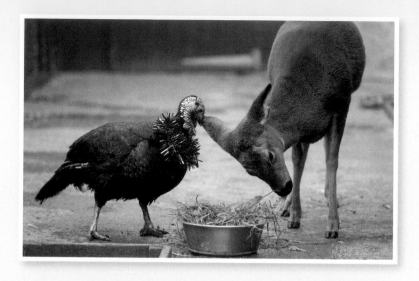

The Turkey *and the* Deer

TINSEL THE TURKEY'S TALE BEGAN, APPROPRIATELY, RIGHT around Christmas. She was packed onto a truck with crates of other birds, all destined for holiday dinner tables. Who knows if she sensed she was in danger and took a leap of faith, or if the truck swerved and she was thrown from the back onto the road. Either way, despite the hard landing, it was a true holiday gift for her to hit the pavement instead of the market.

"Another lorry driver saw her in the road and stopped to pick her up," Geoff says. "She was just a little thing and had pretty bad leg injuries and scratched-up skin. So he brought her to us."

Meanwhile, Geoff had recently taken in a fawn he called Bramble. The little animal, maybe two weeks old, had been unconscious in a field when some folks walking their dog came upon him. His mother

DOMESTIC TURKEY

KINGDOM: Animalia
PHYLUM: Chordata
CLASS: Aves
ORDER: Galliformes
FAMILY: Meleagridinae
GENUS: Meleagris
SPECIES: Meleagris gallopavo

was nowhere to be seen. Geoff, of course, agreed to care for him and tucked him into a bed of hay in his shed, hoping he'd come back to life. Wonderfully, he was roused from his coma when one of Geoff's dogs began licking him.

"We put Tinsel next to Bramble's pen, where the deer was lying down," he recalls. "The turkey walked right in and settled down between the deer's front legs. They were instant friends." As companions, they walked around the yard together, nuzzled, played, and shared naptime. At night, Tinsel would peck gently at Bramble's fur and ears, grooming him. "Bramble just loved it. He'd put his head down and let her peck away."

Compared with mammals, turkeys aren't terribly long lived. And this one was bred specifically to be poultry—which, even if it escapes the pot, means a particularly short existence. So Tinsel passed away after about two years as Bramble's best friend. The loss was very hard on the deer, Geoff says. "He was clearly upset. He'd sit in his pen not really moving around much. He wouldn't eat." Bramble, for Geoff, answered the question of whether a deer can mourn a loved one. "That's really what was happening," he says.

But time heals, and the deer, now an adult and 5 feet tall, is doing fine, says Geoff. "We put another bird in with him, a Canada goose named Cleo. They don't have as strong a relationship as Bramble had with Tinsel, but at least he has company."

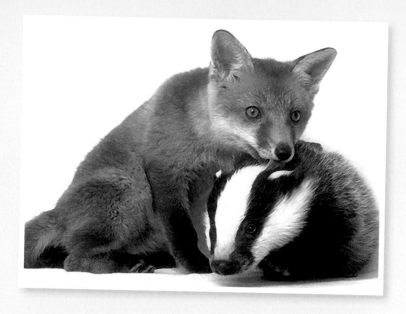

The Badger *and the* Fox

WELL BEFORE THE TURKEY MET AND FELL FOR THE FAWN, the Warwickshire Sanctuary was the setting of another love affair, between a badger and a fox.

"Both arrived tiny, just a week or so old, and we had to hand rear them," Geoff says. Lulu the badger had been found lying helpless and alone in a garden in Coventry, while Humbug the fox was rescued from a railway embankment near Stratford. "We put them in the same pen, and they instantly took to each other." Soon they were nosing each other, wrestling, running, and playing tag. In one game, the fox would jump over the badger and the badger would try to follow

suit—but he was a bit round, not as agile as the svelte fox, and couldn't make it. (Both animals were feeding well. Thus, the round badger.) They'd end up in a happy heap of fur on the ground.

BADGER

KINGDOM: Animalia
PHYLUM: Chordata
CLASS: Mammalia
ORDER: Carnivora
FAMILY: Mustelidae
GENUS: *Meles*
SPECIES: *Meles meles*

Geoff knew from the start they wouldn't grow old together, as Humbug would likely be released back into the wild while Lulu, who it turned out had poor eyesight, would stay put at the sanctuary. Still, "They got so close, the two different creatures, it was a beautiful thing," Geoff says.

Both animals are gone now, but they've left behind quite a legacy. Geoff says Lulu and Humbug were the animals that prompted him to open his sanctuary. So, in addition to making each other's lives nicer, these unlikely friends gave better lives to Tinsel, Bramble, and hundreds of other creatures in need of a good home.

I'd say his animals have given Geoff a much better life, too. He agrees.

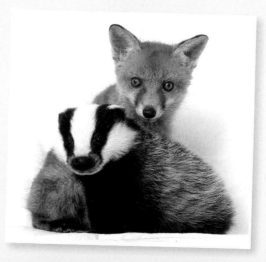

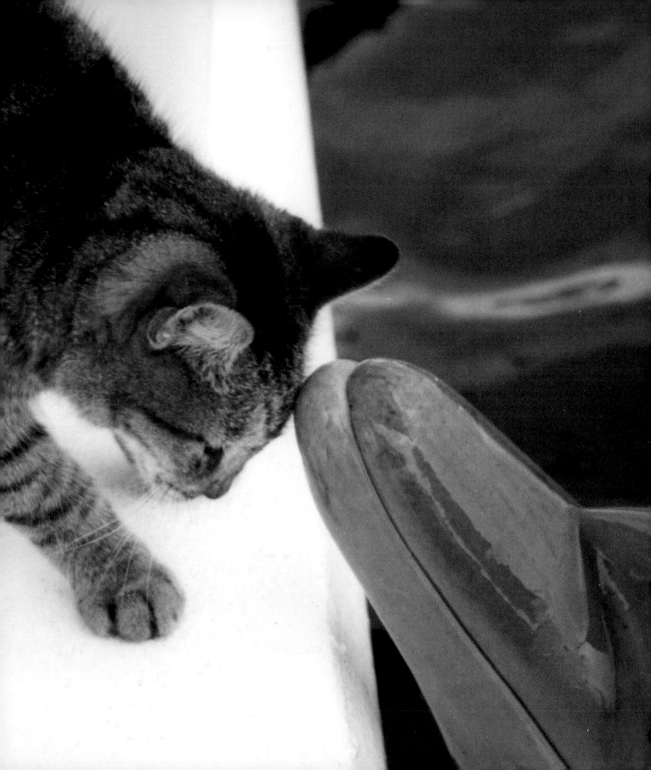

The Dolphin and the Stray Cat

EARLIER I DESCRIBED MY EXPERIENCE DALLYING WITH A dolphin in the waters off southern Ireland. Ask around, as I have, and you'll find that all kinds of people share the desire to get close to dolphins. There's something about these aquatic mammals—not just that permanent smile (which actually has nothing to do with mood and everything to do with feeding), but their curiosity, playfulness, exuberance—that makes us want to get to know them, and to reach out a hand to touch one.

But is the yen to sidle up to dolphins, to reach out to them, also a feline thing? Apparently, yes, if Arthur is any indication.

Arthur was a mixed-breed cat, one of the many strays to make his home at the Theater of the Sea marine park in the Florida Keys.

BOTTLENOSE DOLPHIN

KINGDOM: Animalia
PHYLUM: Chordata
CLASS: Mammalia
ORDER: Cetacea
FAMILY: Delphinidae
GENUS: Tursiops
SPECIES: Tursiops
truncates

Opened in 1947, the family-owned destination is a happy place for homeless felines, with plenty of animal-loving people around, endless fish bits to nibble, and lots of outdoor napping spots warmed by the Florida sun.

For Arthur, there was the added bonus of the dolphins. The way some cats chase moths and others a ball on a string, this cat had a special penchant for big, smooth-headed creatures that popped up like puppets from the water, flinging salty water at passersby. Arthur, like the human visitors to the park, just wanted to be near them.

"He was a friendly guy, maybe about 15 pounds, definitely the boss among the cats," says Janie Ferguson, who then ran a photo concession booth at the park and whose husband shot video of the animals.

Arthur was also fearless. So fearless, in fact, that when visitors would go out to the platform in the 25-million-gallon lagoon where the dolphins were housed, Janie says, "He'd walk out with us to the float to get a look at the animals himself."

It started as just inquisitive observation from well back, but with two curious-by-nature species involved, it quickly became something more intimate. Arthur began going to the edge and engaging with the dolphins directly. "They'd nudge him with their beaks and he'd bat at their faces—not with claws, just gently—and he'd even rub his head against them," says Janie. "One in particular, named Thunder, really seemed to like him." The cat would prance back and forth along the

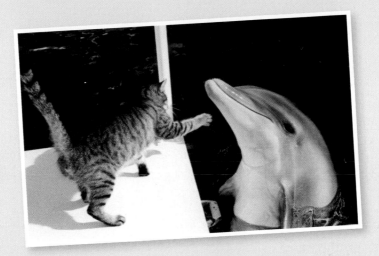

platform edge and Thunder would swim up and back in reply, then bob up high so Arthur could reach him for a cheek-to-beak caress. "Each dolphin really has its own personality," Janie says. "And Thunder revealed his when it came to Arthur." Arthur showed his stripes, too. "The cat was very sure of himself, looking for a little adventure."

And Thunder wasn't rewarded by the trainers for interacting with the cat, she points out. "It just happened naturally. Visitors loved it, of course."

But as much as he relished playing with Thunder, Arthur did stick by housecat rules. Unlike dogs that have befriended dolphins, Arthur never leaped from his relatively dry perch for a swim (and, as far as anyone knows, he never fell in by mistake). I guess love has its limits.

Arthur has since passed away, but he's remembered for his bold moves on the dolphin platform, crossing species boundaries (and risking a cold dunking) in the name of friendship. He was, Janie says, "a very good soul."

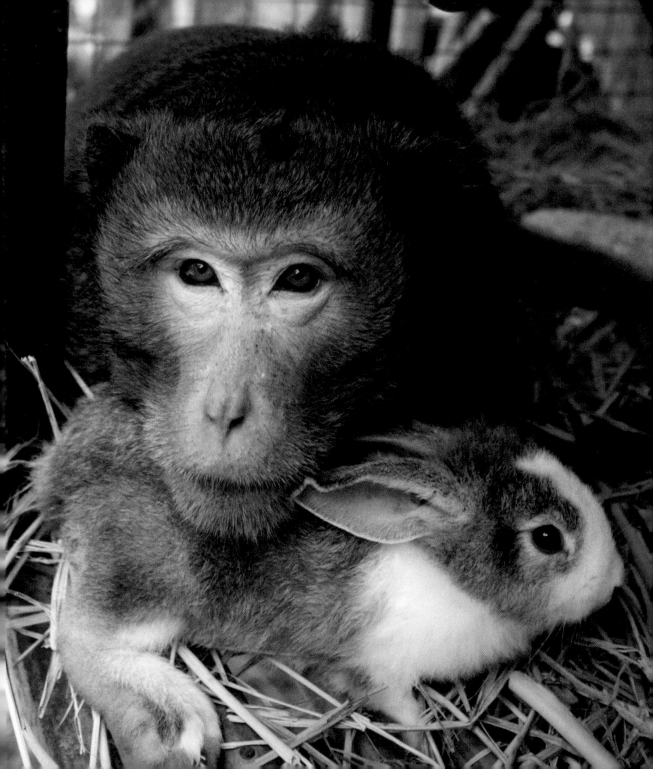

The Macaque, the Rabbit, and the Guinea Pig

THIS NEXT STORY IS NOT FOR THE FAINT OF HEART, BUT I promise it has a happier ending than beginning.

Boonlua is a long-tailed macaque—a pinkish-faced fruit-loving primate of Southeast Asia that thrives high in the trees of tropical rain forests. Back in 2005, he was living wild in a place called Lopburi in Thailand when he had a near-death experience that would change everything.

The macaque had come down from the safety of the trees one day when he met up with a pack of vicious dogs. Macaques can

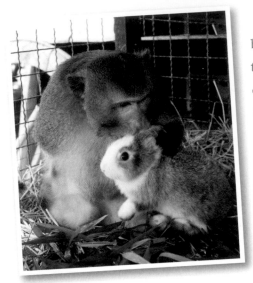

be plenty feisty when threatened, but the dogs were too much for him, literally tearing him to pieces—he lost both legs and an arm in the attack. Left bleeding and no doubt in tremendous pain, the primate was certainly near death. Yet rather than give up, somehow, with just a single limb remaining, he dragged himself to a nearby temple. Whether the wild animal somehow knew to go to people for help or was just seeking shelter, no one knows. But he ended up in the right place.

When the monks saw the poor creature on the temple steps, they called a vet who, remarkably, saved the animal despite his terrible injuries. The monks then brought him to a place called the Royal Elephant Kraal, which took in animals needing special care.

Former zookeeper Michelle Reedy, Operations Director of Elephantstay (a nonprofit elephant conservation arm of the Royal Elephant Kraal), designed a special enclosure for Boonlua to accommodate his specific needs and abilities. He seemed to feel safe in his new environment, and soon he was so healthy and active that people hardly noticed he was missing so many parts.

LONG-TAILED MACAQUE

KINGDOM: Animalia
PHYLUM: Chordata
CLASS: Mammalia
ORDER: Primates
FAMILY: Cercopithecidae
GENUS: Macaca
SPECIES: Macaca fascicularis

♥

With the animal doing so well, the staff became busy with other tasks and Boonlua soon seemed forlorn being left alone. "We decided he needed a friend," says Ewa Narkiewicz, the communications director at Elephantstay. "But we could not give him another monkey because of his disability." If the relationship became aggressive, Boonlua would be unable to fight back. "We decided to try a rabbit and see how they got along." So caretakers brought in Stripe, as well as a guinea pig, Curlywurly Brian.

GUINEA PIG

KINGDOM: Animalia
PHYLUM: Chordata
CLASS: Mammalia
ORDER: Rodentia
FAMILY: Caviidae
GENUS: *Cavia*
SPECIES: *Cavia porcellus*

Despite his habit of nabbing his favorite nibbles from his two furry companions' food bowls, the macaque is clearly smitten with Stripe and Curlywurly Brian, and they seem unaware of his disabilities, as, it seems, is he. "He used to sleep stretched out on the wooden poles above the floor, but now he stays at the bottom of the enclosure to be as close as he can to the others," says Ewa. "Even with just one arm, he spends a lot of time grooming the rabbit and the guinea pig. He gets very jealous if others pay too much attention to them—he clearly thinks they belong to him. He's like a possessive husband!"

"It's been so important for Boonlua to have constant company," Ewa adds. "He still enjoys being scratched by the guests and holding on to human fingers. Primates do require more stimulation than some other species. But he has been helped enormously by having these furry friends, who have given him something of his own to focus on." Their good relationship and Boonlua's recovery, she says, "show how

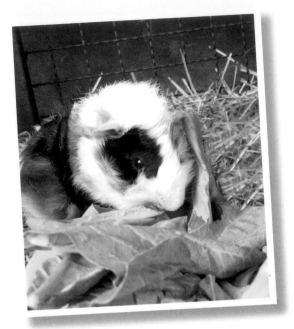

adaptable animals are to all kinds of circumstances."

For a once-wild animal that barely survived a violent attack, lost most of his limbs, and has suffered stretches of deep loneliness, Boonlua now has two very soft and sweet reasons to live.

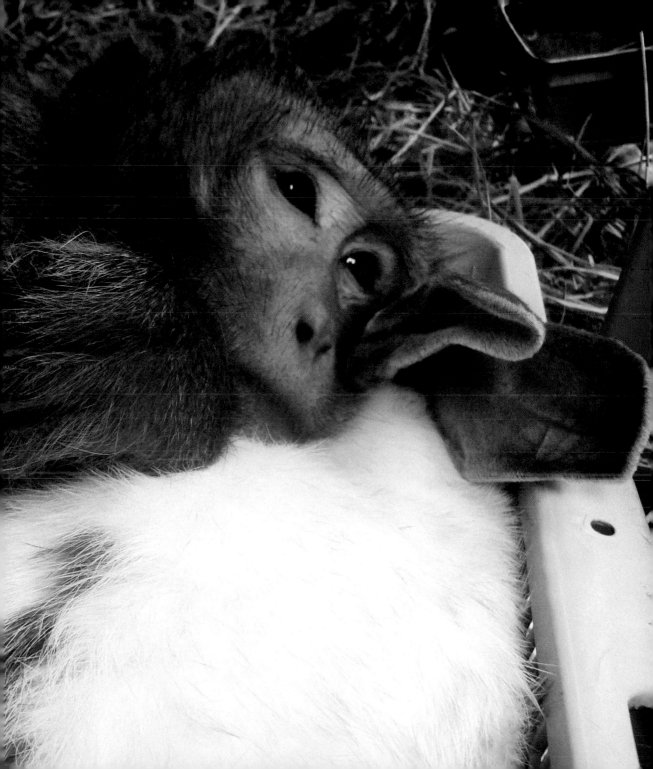

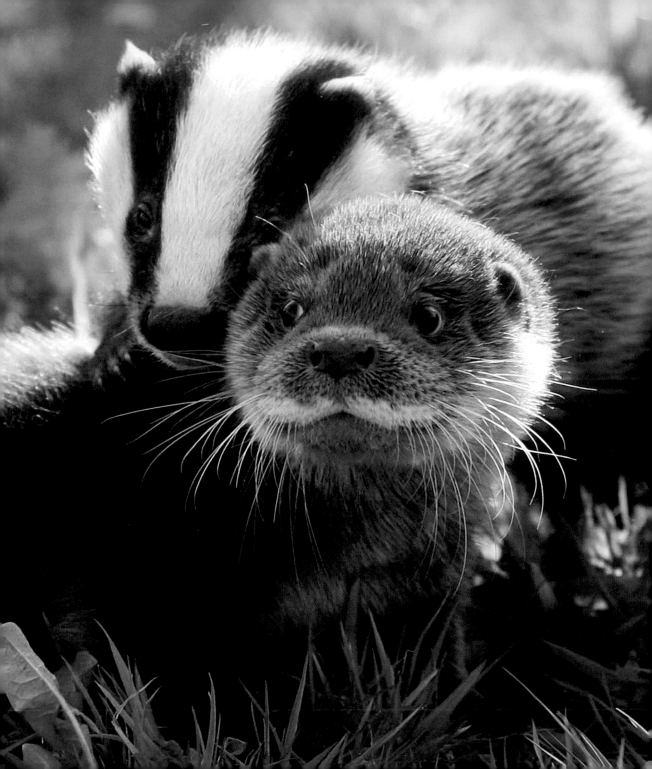

The Otter
and the Badger

HERE IT IS, THEN, A TALE OF TWO MUSTELIDS. IT'S A sensory tale, in a sense. Because what makes a mustelid a mustelid is how it smells.

Let me explain. This group of animals is known for the special gland near the base of the tail that gives off a musky scent. Family members spread their unique odor on each other; it tells them who is kin and who is stranger. But in this story, friendship was stronger than fragrance, and two different-smelling creatures bonded like brothers.

"It was a cold, rainy day in March," begins Pauline Kidner, founder of Secret World Wildlife Rescue, located in Somerset in the southwest of England. "We had a report from Devon of an otter cub

found near its dead sibling. The person who found it managed to pick it up and wrap it in a towel because the cub was very wet and cold."

Back at her rescue facility, where she and her loyal team care for some 5,000 wildlife casualties a year, Pauline tucked the orphan—whom she called Torrent—into an incubator to boost his body temperature. Skinny and cold to the bone, he was maybe eight weeks old and by no means guaranteed survival. But soon he was wiggling around, stretching his tiny limbs, and she put him into a pen in the kitchen to give him more space. So far, so good, Pauline thought. But when she tried to bottle-feed him, he refused to drink. "Even using a syringe, he wouldn't take it," she says. "He wasn't interested. He was whistling constantly, grieving and lonely and wanting his mother. I gave him soft toys with warm wheat bags to snuggle up to, but he still wouldn't settle."

As it happened, Pauline had three badger cubs in her care, brought to her by kindly people who had spied the young animals in peril (two had been on a road with cars driving around them and the other was lying alone and very cold in a field).

The badgers and Torrent were about the same size, so Pauline decided to put them together, hoping companionship would calm the stressed-out otter. It worked. "Torrent immediately snuggled up with the badger cubs and went right to sleep," she says. "As they all started to wake up about two hours later, the badger cubs were intrigued by their new friend and included him in their favorite tussling games, biting

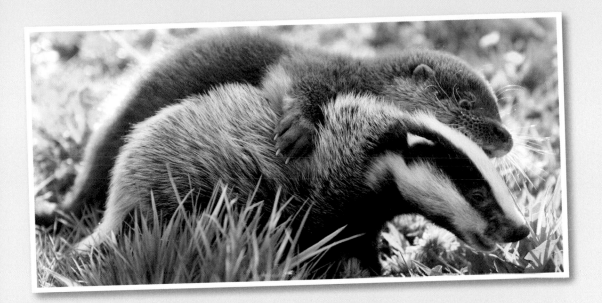

each others' ears and rumps. Torrent quickly got the hang of it!" Of course, the different species don't just smell different but also vocalize in dissimilar ways—the badgers "whickering" and the otter squeaking and whistling. "Yet," Pauline marvels, "they all seemed to understand each other."

When that all-important feeding time arrived, Pauline was relieved to see Torrent follow his new friends' lead. As the badgers ran for their bottles, the otter did the same, competing for the best spot, latching on, and sucking down his meal. Now, Pauline felt, Torrent would surely survive.

He didn't just survive. He thrived! The badgers did, too. Spirited by nature, they spent hours chasing each other around the kitchen table and over the chairs, and wrestling over fir cones in the old fireplace. Pauline had to feed them separately once Torrent graduated to a fish

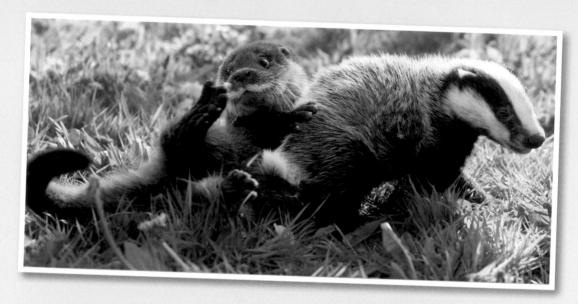

diet—"once he started sticking his nose in the dog's water bowl, we knew it was time"—but their rough-and-tumble friendship continued to grow apace.

As Torrent began swimming lessons and doing more otterlike things, Pauline felt the relationship with the badgers had served its prime purpose—to get Torrent eating and to socialize him—and it was time to give him a companion like himself. This would help prepare him for his eventual release back to the wild.

Luckily, just as Torrent was weaning, someone dropped off a young female otter, called Rain, that had been found alone in a parking lot near a river. An easy friendship was born between the two animals—shall we even suggest a love affair? They lived for a time in the grassy otter pen outside, where they could swim in a big pond and race around at

the water's edge. And one year later, Pauline released them together by a lake in the countryside. Whether they went on to mate is anyone's guess, but we can hope!

Meanwhile, the badgers eventually became a family of six when Pauline added more orphans to the mix. (When young animals are brought in, she puts them together according to size and age and lets them scent each other, in a sense creating families out of unrelated animals.) The whole clan was released in the autumn of the same year, Pauline says, "at a lovely woodland site. Hopefully by now they are having cubs of their own."

OTTER

Otters spend 80 percent of their time on land but are very proficient swimmers. They mostly employ their whiskers to sense their prey (for example, fish), but they also have the ability to smell underwater!

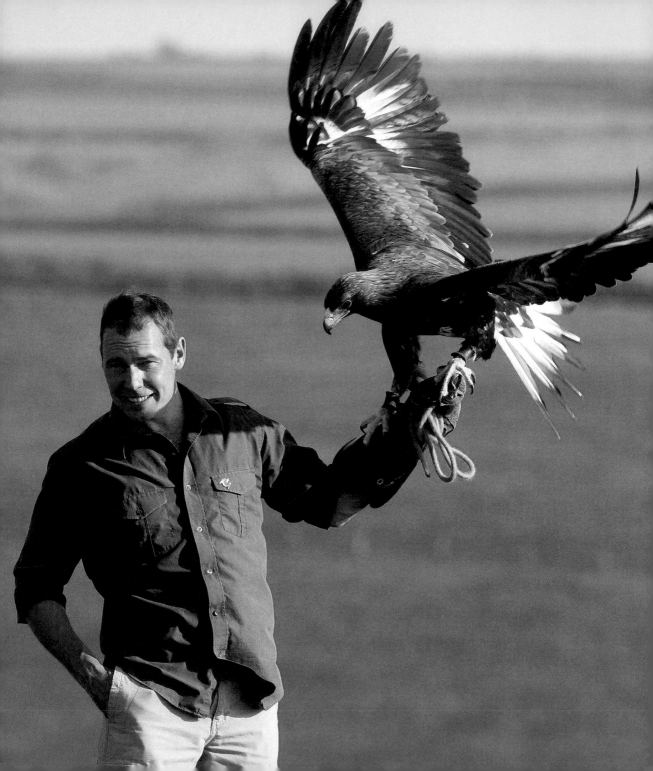

The Golden Eagle *and the* Flying Man

ON ANY GIVEN DAY, IF THE WEATHER IS FINE, AND YOU happen to be hanging out in South West England, turn your gaze to the sky. If you're very lucky, you might just catch sight of a marvelous thing.

Two things, actually. A man in his flying machine. And a glorious bird soaring beside him. No coincidence: This pair, man and bird, share a bond that rivals many human relationships. This is Jonathon the falconer and Sampson, his prized golden eagle.

Sampson had a sad beginning. Stolen from a zoo as a very young bird, he was kept locked in a cupboard by the thief, in Yorkshire. He was "pretty smashed up" and aggressive when Jonathon rescued him. But once the bird came to Devon and

GOLDEN EAGLE

KINGDOM: Animalia
PHYLUM: Chordata
CLASS: Aves
ORDER: Accipitriformes
FAMILY: Accipitridae
GENUS: *Aquila*
SPECIES: *Aquila chrysaetos*

got proper care, he thrived. And within a year of their partnership, Jonathon, who flies a cherry-red microlite aircraft, had Sampson gliding next to him 2,000 feet up, on long, luxurious trips across the English countryside and along the coast. "I tell him my secrets," Jonathon told me. "He really listens, and I think on some level he understands."

Jonathon has been working with raptors and horses most of his life, and he and his animals put on shows all over England to show off their grace and intelligence, to teach audiences, and to entertain them. The crowds love to see the raptors up close and to watch how beautifully the man and his animals respond to one another.

At one of those shows—a wedding at a castle in Gloucester some 200 miles from their home in Devon—Jonathon and Sampson were unable to perform because of torrential rains. He and the bird got soaked through, so when the weather cleared, "I took the birds out to fly them, so they could dry off," he says. "Sampson flew up over the castle into the clouds, and disappeared."

At first Jonathon wasn't concerned; he'd always given his birds freedom and Sampson wore a radio tracker so his movements could be monitored. "But after an hour, we went looking for him, and we found the tracker on the ground, chewed off. At that point I was frantic. I knew we'd truly lost him."

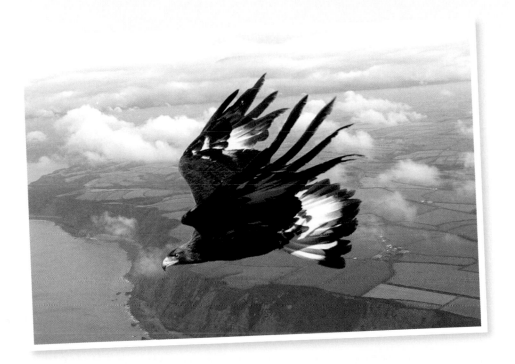

Jonathon had to take his other birds home. "But every day, I drove three hours back to Gloucester to look for him," he says. Jonathon couldn't sleep, and couldn't eat. "I was just so worried about him. My life is all about horses and birds, they're my family, so this was for me like having one of my kids run off." But wandering the hills of Gloucester looking for a bird "was like finding a needle in a haystack, as they say. So I asked a friend with a radio station to tell listeners to report if they sighted the eagle—not a bird you see around here normally, especially one with a seven-foot wingspan." And soon enough, the emails started coming in. Someone had seen an eagle in Bristol, then another spied him down along the Somerset coast, and later someone reported him flying inland.

And then, on the seventh day after he disappeared, Sampson returned. Not to Gloucester, but all the way home to Devon, some 250 miles from where his freedom flight began.

Whether the bird got lost for a time or just wanted a solo adventure, no one knows, but his return "was a huge relief," Jonathon says. It was during a performance with some of his other animals that, suddenly, the eagle swooped into the arena—as if he'd been waiting for his cue. "I got all choked up when I saw him," Jonathon says. His tears spoke of relief, and of love.

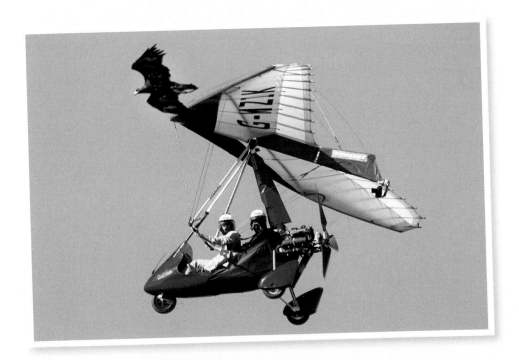

It's hard to know what Sampson felt about seeing Jonathon, but the fact that he traveled so far to get home says a lot. Also, "since Sampson doesn't have a female mate, he is pair bonded with me—he sees me as his partner," Jonathon says. And golden eagles pair for life.

Obviously Jonathon's relationship to Sampson is a little different, but the bond is just as tight. And when the two are separated for an extended time, the bird is clearly unhappy. "I had a friend take care of him over the winter while I was in Spain, and my friend said he seemed sulky, despondent." When Jonathon went to retrieve the bird after three months, "he clearly brightened up. He was calling to me; I have no doubt he recognized me and was happy to see me. My friend said the change in him was unbelievable."

After his experience losing Sampson for a time, will Jonathon keep him tethered or caged so he can't do another flyabout? Absolutely not, he says. "Freedom is only a big deal if you don't have it. I trust him. If I were to restrict him now, it would be counterproductive." And it would be unfair to Sampson, he says. "He's an eagle. He needs to fly."

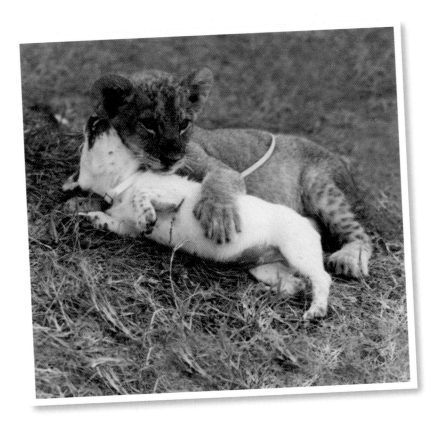

The Puppy and the Lion Cub

SOME PEOPLE TALK ABOUT RUNNING OFF TO JOIN THE circle. Other people actually do such things. In this case, it was the carnival rather than the circus, but let's not split hairs. We're talking hot summer days, the smell of fried food and wet straw, the tinkling of music from the carousel, questionably safe rides that whip kids into a screaming frenzy, and exposure to some odd folks and mighty cool animals. That's the life Marcy and Mickey Berra were leading back in the late 1970s when they became parents to a lion.

Mickey was son to a carnival man, and he and his brothers continued traveling and working the games in the summer for years after their father died. Mickey eventually changed careers,

LION

KINGDOM: Animalia
PHYLUM: Chordata
CLASS: Mammalia
ORDER: Carnivora
FAMILY: Felidae
GENUS: *Panthera*
SPECIES:
Panthera leo

but a year after he and Marcy married, they decided it would be a fun adventure to return to Mickey's roots.

"We took a dime pitch and a couple of kiddy rides and joined Gooding's Million Dollar Midway show, where [Mickey's] brother Wayne still worked," Marcy recalls. "I was twenty-five and had an adventurous streak."

It was a wild ride. While immersed in this strange world, the couple bought a puppy called Alvin from a man named Wrong Way Terry. "He cost a six-pack of beer," Marcy says, and was smaller than one. "You could hold him in one hand!"

Next stop for the carnival was Chicago's Navy Pier. While there, Wayne put in an order to buy Sabrina, a nine-week-old lion cub, to keep as a pet.

Times have changed since then. Nowadays, such exotic animals are illegal to own in many states—both for the good of the animals and the safety of the people. But back then, having the lion was perfectly legal. When she was delivered, the family was excited to see how their respective pets would get along. "We put Alvin and Sabrina down on the ground together, and they immediately started to play," says Marcy. "Sabrina wanted to lick Alvin clean, and though he was a little friskier than she was, they bonded right off the bat. They played all the time."

When the carnival season ended, Marcy, Mickey, and Alvin went home to their high-rise in Crystal City, Virginia. It was a no-pets

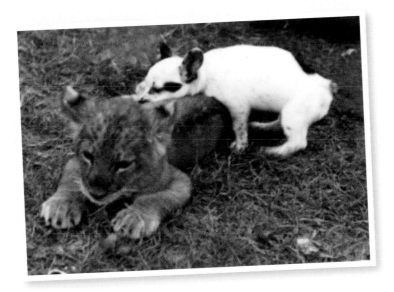

building, but Alvin didn't cause a scene. "However, shortly after we came back, Wayne came to visit with Sabrina," says Marcy. "He asked if we could watch her while he went to Pittsburgh to visit their mom." They snuck the now 75-pound lion up to the apartment in the service elevator, where Alvin and Sabrina were happily reunited. "They hadn't seen each other for a couple of weeks and were so happy to be back together. They chased each other around the apartment and slept together just like old times."

Wayne's brief trip turned into a five-month absence. Each day Marcy took the animals to the park, "and most people would do a double take when they saw us." She says it was great fun to ride the elevator with other people with the two animals in tow. "They were never sure

what to think. You know how people in an elevator look straight ahead, avoiding eye contact, but then you catch them glancing? There was a lot of that. Sometimes they would ask incredulously, 'Is that a lion?'"

As for the animals' personalities, Alvin was a hyper little guy, happy to chase a ball and play for hours. Sabrina was more laid back. "She was a licker—she loved licking your face, and a lion's tongue is much rougher than a house cat's, so it was like getting a facial every time!" Though never vicious, Sabrina did not like to be bothered while eating. (She was, after all, a lion.) But the cat's best friend Alvin was an exception. "He would crawl right between her legs and eat her food, no problem."

BIG CATS

According to the nonprofit Big Cat Rescue, big cats such as lions are pound for pound twelve times as strong as a human, grow very fast, and retain their natural instinct to kill—all of which make them very dangerous pets. For more information about the laws on big cat ownership throughout the United States, take a peek at bigcatrescue .org/state-laws-exotic-cats.

Finally, Wayne came back for Sabrina. He had found her a home with Lion Country Safari in Florida, where she could be with other lions and have space to be a big cat. But before she was sent off, Marcy and Mickey wanted to see her one last time. "We paid a visit and she was so happy to see all of us. She gave Mickey a big hug. At this point, she had to weigh well over 125 pounds," so Marcy declined such an embrace. Most important, "she was still loving toward Alvin," Marcy says, "although he was running circles around her. But clearly their time apart hadn't changed anything between them."

Those were unusual times, Marcy says. "As much as we loved our experience with Sabrina, and were thrilled at her friendship with Alvin, looking back I think it was terrible that people could just buy a wild cat like that." Not everyone who keeps such animals takes good care of them, and there has been much abuse and neglect by owners. Marcy isn't a fan of caging animals at all—she doesn't even like fish tanks, she admits. So though it was a true adventure for the people involved, and a true love story for the animals, "I'm very glad the laws have changed."

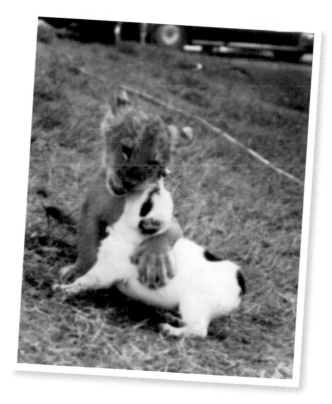

Modern Family Love

> "There is only one kind of love, but there are a thousand different versions."
> —*François de La Rochefoucauld*

BACK IN THE OLD DAYS, "FAMILY" MEANT A VERY PARTICULAR THING. These days, the word's definition is being stretched every which way, and it's a wonderful evolution. Today's family may include a mix of lineages, may be multiethnic and multicolored, may have a brother who was once a sister (or vice versa), two moms and no dad (or vice versa), and so on.

These next stories might be said to represent modern families among nonhuman animals. We have a bit of unconventional mating but mostly you'll find creatures that have found family-like ties in some unexpected combinations. It's not a neat and tidy category of love, just as family life and relationships are never neat and tidy. This book, after all, is about mixing things up and shattering expectations.

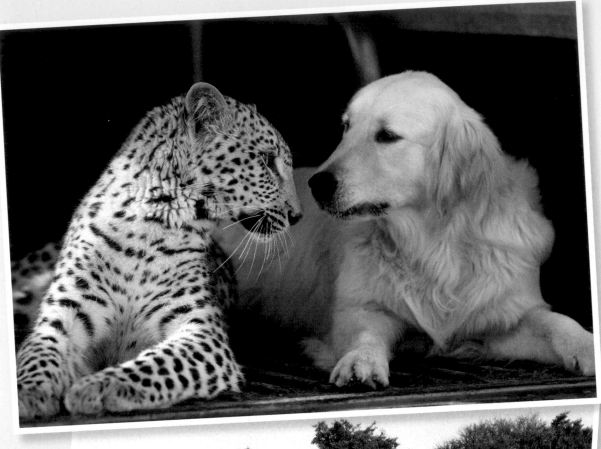

Tales from
Glen Afric
Wildlife
Sanctuary

THERE'S SOMETHING ABOUT AN **A**FRICAN WILDERNESS that gets the human heart pounding. And the mammals that roam these faraway places are what wild *is*. Elusive. Enduring. Vulnerable. Utterly beautiful.

So stories that include African animals, especially when those animals are showing affection and emotion in ways that remind us of ourselves, seem to tug at our hearts extra powerfully. In these next two tales, creatures with roots in such a landscape, normally so out of reach for most of us, are caught up close doing just that.

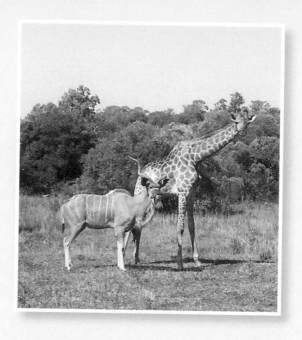

The Kudu *and the* Giraffe

FIRST, LET'S TAKE A PEEK AT A GIRAFFE AND A KUDU IN South Africa that broke species rules for love.

A few years ago, a calf named Camilla fell 6 feet to her birth. That is, a giraffe named Lucy had a baby, Camilla, and, as giraffe calves begin life dropping to the ground from their standing mothers, she endured the trip down. "Baby giraffes are adorable as newborns," says Jenny Brooker, co-owner of the Glen Afric Wildlife Sanctuary. "They look like they come straight out of a toy shop!"

Camilla grew strong and as tall as, well, a giraffe (females top out at around 16 feet). It was a good life at the sanctuary, where many species roam freely—from wildebeest and hartebeest to warthog, waterbuck, zebra, and impala. There's a hippo, some leopards, and a pack of spotted hyenas. There are also some lions in large enclosures and some tame elephants, but "most of these animals remain wild," Jenny explains. "We don't touch them but we have a wonderful relationship with them, a great trust, and they will come close to us." In that environment, wandering in a natural setting but watched over by animal-loving people, the young giraffe was at home.

And then one day, an unlikely suitor came calling on lovely Camilla. "About two years ago, a young male kudu came from the wild herd that lives in our back mountains," Jenny says. "He took one look at Camilla and fell in love!"

A kudu is a type of antelope (there are "lesser" and "greater" species, having to do mostly with size). They usually have a badge of white between the eyes and thin white stripes drizzled down their sides from a crest of hair along the back. Males get giant curly horns—those of the greater species can grow beyond 70 inches, with a graceful two-and-a-half twist. Some also have little white beards.

This kudu was of the greater species and he was a persistent bugger. His affection led to "a most unusual love affair," Jenny says. "Whenever we saw Camilla and Lucy, there was the kudu. He followed his girlfriend everywhere!" It became obvious to the staff that the kudu was Charles to the giraffe Camilla, so the name stuck.

GREATER KUDU

KINGDOM: Animalia
PHYLUM: Chordata
CLASS: Mammalia
ORDER: Artiodactyla
FAMILY: Bovidae
GENUS: *Tragelaphus*
SPECIES: *Tragelaphus strepsiceros*

Jenny says the couple would be spotted nuzzling each other from time to time, and if the kudu wandered too far from the giraffes, "Camilla got quite agitated and looked for him. Clearly the affection went both ways from early on."

Two years after Charles showed up in Camilla's life, the two are all grown up and still roaming the bush together, trailed by chaperone (and mother-in-law) Lucy. The mixed-species couple seems content in their strange union. Jenny points out that these animals were not hand raised or interfered with by humans at all. "They were born in our sanctuary but are free and wild like the other animals here," she says, which makes this relationship all the more unexpected. Male kudu sometimes stay in bachelor groups but are mostly solitary. Who knows why this one latched onto a companion, particularly one of a different species? Whether the affair with Charles will end if Camilla finds a giraffe mate is also up for speculation. No doubt rumors will run wild.

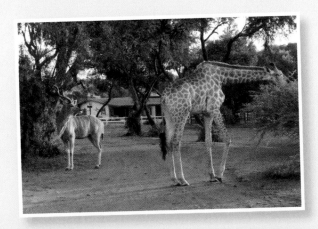

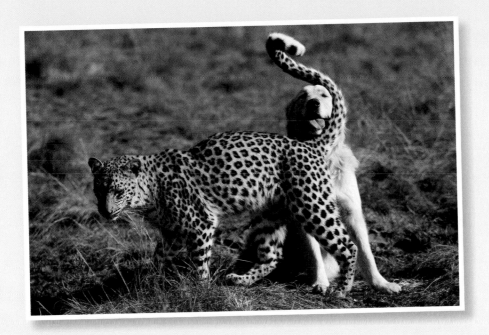

The Leopard *and the* Dog

MEANWHILE . . .
In this tale, there's a spotted feline leaning on a canine for affection. Selati came to the Glen Afric rehab center at about three weeks old, the only survivor of a litter of four leopards.

"We are often called upon to hand raise young orphans of all kinds," says Jenny Brooker. "From baby elephants and zebras to giraffes, donkeys, and kids [baby goats], we have done it all here." Well, almost all. At that time, for the rehab team, "a leopard was a new challenge!"

LEOPARD

KINGDOM: Animalia
PHYLUM: Chordata
CLASS: Mammalia
ORDER: Carnivora
FAMILY: Felidae
GENUS: *Panthera*
SPECIES: *Panthera pardus*
SUBSPECIES: *Panthera pardus pardus*

Fortunately, the cat proved an easy baby: "She took very well to the special milk formula we gave her, and soon began to suckle contently on her bottle," Jenny recalls of the first week of Selati's care. Jenny has a nursery at home, so she can monitor young animals through the night, getting up to feed them over and over in those early weeks. So Selati was immediately exposed to her four dogs, her cat, and her children, all of whom took a liking to the new resident. The leopard quickly settled on a favorite: Tommy.

"Selati bonded with Tommy immediately. He is such a gentle dog. He even lets baby chicks climb all over him."

As Selati grew, she only became more agile and rambunctious. Jenny recalls: "She would climb on top of everything, jumping off cupboards onto our backs as we walked past. Yet she was ever gentle—she never had her claws out." Jenny's children would take all four dogs plus the leopard for long walks on the farm, down to the dam, where the dogs loved to swim and the kids had mud fights. And though most of us tend to think cats and water don't mix, Selati was happy to plunge in with the rest of them and paddle around, playing games by rules only the animals understood.

Of course, big cats need big space. Also, Selati really required a secure environment—less for her own safety than for that of new arrivals to the nursery. (The leopard, now adolescent, could be a bit too physical with the babies.) So the Glen Afric team built her a large enclosure with lots of trees for her to climb. This was vital for the

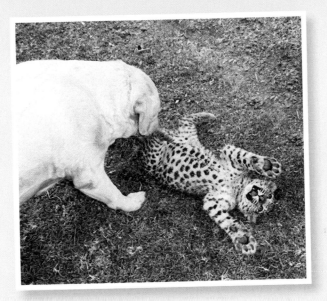

leopard's continued good health, though removing her from her "family" was hard for everyone, Tommy in particular.

Still, to combat any potential loneliness, "every weekend, we put Tommy in the car, collected Selati, and drove to the back mountains to take long walks together. And the bond between Selati and Tommy has only grown more incredible." The two animals play hide-and-go-seek in the tall grass, one pouncing on the other, or stroll side by side like a long-married couple.

Soon, Selati may take a mate and move on with her leopard life. But even if Tommy becomes a less prominent figure in the leopard's life, "I am quite sure she will never forget him," Jenny says. And Tommy, Jenny believes, will always hold Selati tucked away in his heart.

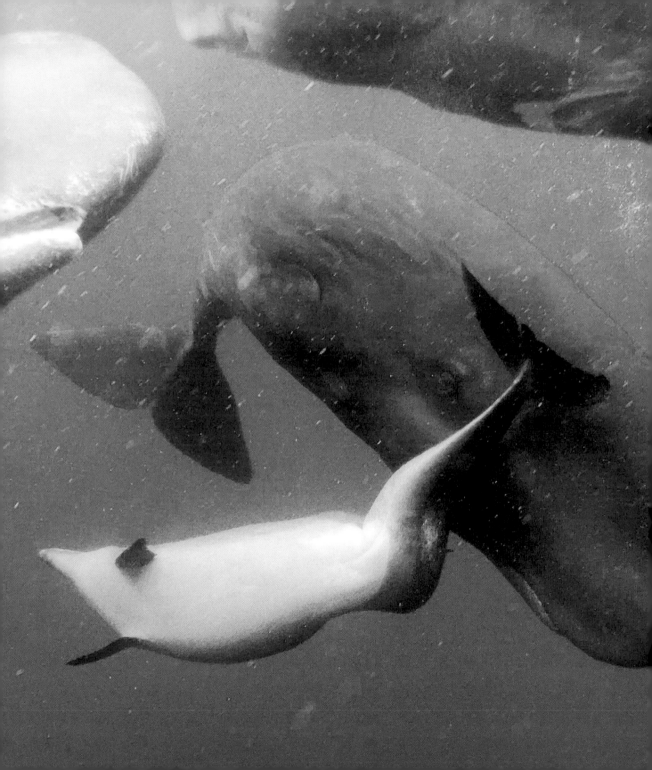

The Dolphin *and the* Sperm Whales

NINE MILES OFF THE ISLAND OF PICO IN THE AZORES, A playful relationship between a dolphin and a pod of sperm whales has animal behaviorists intrigued. The area, an archipelago in the North Atlantic, is a food-rich crossroads of ocean currents, which brings a host of marine creatures together, including plenty of marine mammals.

Alexander Wilson and Jens Krause, of the Leibniz-Institute of Freshwater Ecology and Inland Fisheries in Berlin, Germany, were in the Azores looking for sperm whales with hopes of beginning a behavioral study of the animals. "Serendipity shined," says Wilson, "when we came upon this interesting encounter." They witnessed a bottlenose dolphin—one that appeared to have a spinal

SPERM WHALE

KINGDOM: Animalia
PHYLUM: Chordata
CLASS: Mammalia
ORDER: Cetacea
FAMILY: Physeteridae
GENUS: *Physeter*
SPECIES: *Physeter macrocephalus*

birth defect—hanging around with sperm whales as if it were meant to be there, one of the family. "We initially assumed it was a short-term thing. But over the course of eight days, we saw them together over and over again. Clearly they were associated in a friendly way."

Dolphins are very touchy-feely animals with their own kind, often rubbing their rostrums (the "nose" part) against each other or sidling up to one another. "It's how they maintain their strong social bonds," Wilson explains. But to see a dolphin nuzzling and rubbing a flipper over the blowhole of a large sperm whale, as Wilson recalls, "was quite something. Sperm whales are physical with each other in different ways. They tend to roll around at the surface, making contact with tails or rubbing lateral flanks together." So here was a dolphin doing dolphin things to whales—and whales seemingly okay with it. And the dolphin was also copying whale behavior, rolling around and playing the way the other mammals do. "It's certainly rare to see so much physical contact between two different species," he says. Especially when their ways of touching are normally so unalike.

Now, as mentioned, this dolphin was a bit unusual to begin with, having a spinal birth defect. "We wondered if that was part of the reason it had taken up with this other species." Perhaps it had trouble keeping up with other dolphins—which may zip along at 25 miles per hour—and so joined a slower-moving group. (Sperm whales *can* rival dolphins in speed when in a real hurry, but typically the behemoths

ease along at 10 miles per hour or less.)

Or maybe, Wilson says, it had to do with the dolphin social structure. "They form a hierarchy, and it's possible this one that looked different wasn't accepted, was harassed

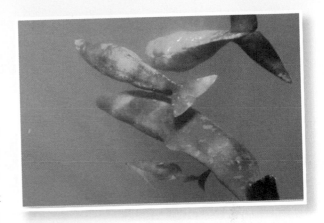

and couldn't compete, so it initiated contact with these other animals that appeared friendlier." Which is quite interesting, he says, since typically, sperm whales are seen acting either aggressively or defensively toward other marine mammals. Yet here, the sperm whales may have adopted the dolphin into their family because it had been tossed out by its own.

Or, could joining a group have simply been a way for the dolphin to thwart predators? Perhaps, but there aren't many animals in the Azores that would prey on a dolphin. So, while this might be a bonus benefit, more likely the partnership for all the animals was about companionship and play.

Wilson chuckles at the idea that the single dolphin and its adopted whale family were emotionally bonded through something like *love*, but he agrees that marine mammals, and especially dolphins and whales, are capable of complex relationships. "They're intelligent and social, so we shouldn't underestimate what might be going on," he says. "Certainly, the interaction fulfilled some need for both species."

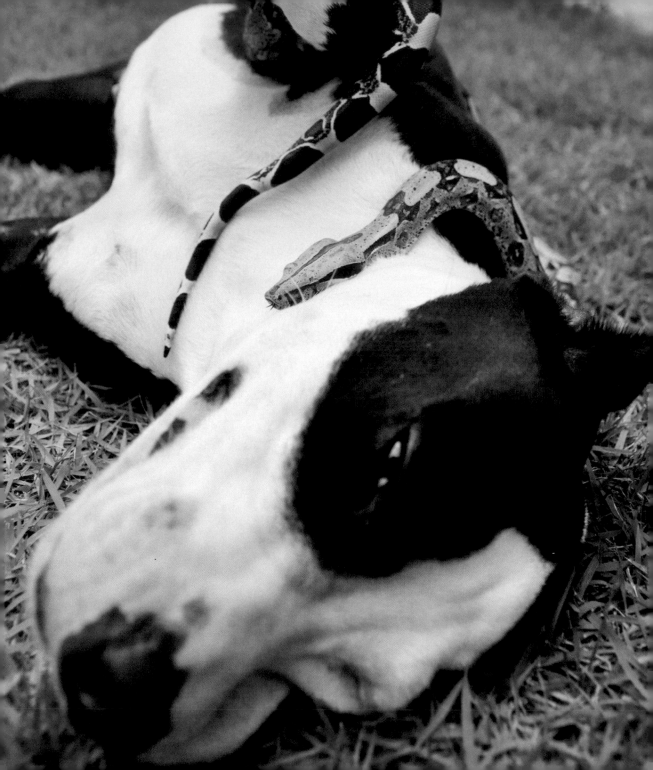

The Boa Constrictor
and the Pit Bull

UILY OLIVERIA LIVES IN RIO DE JANEIRO, THE SECOND-largest city in Brazil, known for crowds and Carnival, for samba, beaches, and Bossa Nova. This thirty-year-old veterinary college student loves Rio's wildness, but maybe not the kind you'd expect. Aside from his wife (also a vet student and big fan of creatures great and small), Uily shares a home with seven dogs, six boa constrictors, an albino python, five tegus (really big lizards), four iguanas, and two turtles. He also keeps a barn owl, two guinea pigs, and, rounding out the zoo, there's a very vocal cockatiel (his partridge in a pear tree, if I may). It isn't uncommon to see Uily out strolling with a dog or three by his side, the owl gripping his forearm, and a snake coiled like a thick scarf around his neck.

BOA CONSTRICTOR

KINGDOM: Animalia
PHYLUM: Chordata
CLASS: Reptilia
ORDER: Squamata
FAMILY: *Boidae*
GENUS: *Boa*
SPECIES: *Boa
constrictor*

Wild life, indeed.

Among that mess of dogs is Laika the pit bull, a stray that friends of Uily's found on the street. Uily adopted her . . . when you already have six, what's one more? And one day, this very loving dog took an unexpected interest in Jack the snake.

"I'd already had Jack for two years when we adopted Laika," Uily says. But once the dog was around, "whenever I was handling Jack, Laika came by and was curious about him, wanting to get close to him." Knowing his snake was gentle (and well fed), and that the dog, too, was sweet of heart, Uily decided it was safe to put the two together. And they got along splendidly.

Uily has come to know when Laika wants a snake embrace. "She loves to lie down on her back and let Jack wind around all over her. She'll even go out walking with Jack around her neck, showing how close they really are." Imagine coming across such a pair strolling down the block. Only in Rio! Or . . . maybe New York. Okay, L.A., too. But that's about it.

Laika is very delicate with Jack. "It seems she knows that if she makes sudden movements, she can hurt him. And she actually seems to relax when Jack is 'walking' over her, like he's giving her a massage." It all appears to be quite affectionate, he says. "Sometimes I leave them together for hours."

Strangers are often skeptical that the dog and boa are intertwined by choice. "I posted a picture of Jack and Laika together on Facebook

and people found it unbelievable," Uily says. "Some were sure I sedated Laika to take the pictures, but one person made me laugh by commenting: 'Look how absurd, a snake killing a dog!' I laughed a lot when I read that, then tried to explain it was a friendship, and that neither posed any risk to the other."

Perhaps part of that reaction is because both of these animals have bad reputations, usually undeserved. Snakes in particular are one of the most feared animals (up there with sharks). Many are killed out of fear, when in truth most snakes want nothing to do with humans and certainly aren't looking to harm us. And of all dog breeds, pit bulls tend to be regarded as the most ferocious, though so many of them are honey-sweet, gentle with kids, and utterly loyal.

Yet, the reputations live on. "The issue is really with the owners, not the animals," Uily says. "The secret to interacting with these animals in a harmonious way is to respect them."

And that seems to be an attitude his animals take to heart, since Laika and Jack do their gentle dance with the utmost kindness, even tenderness. Now, who can say what's going on in that boa brain? But clearly it isn't fear or the desire or instinct to squeeze the life out of Laika. And it's fun, and perhaps somewhat accurate, to put thoughts into Laika's mind as Jack curls and slides along her back: "Hey, pal, can you move a little to the left? *Ahhhhhhhh.*"

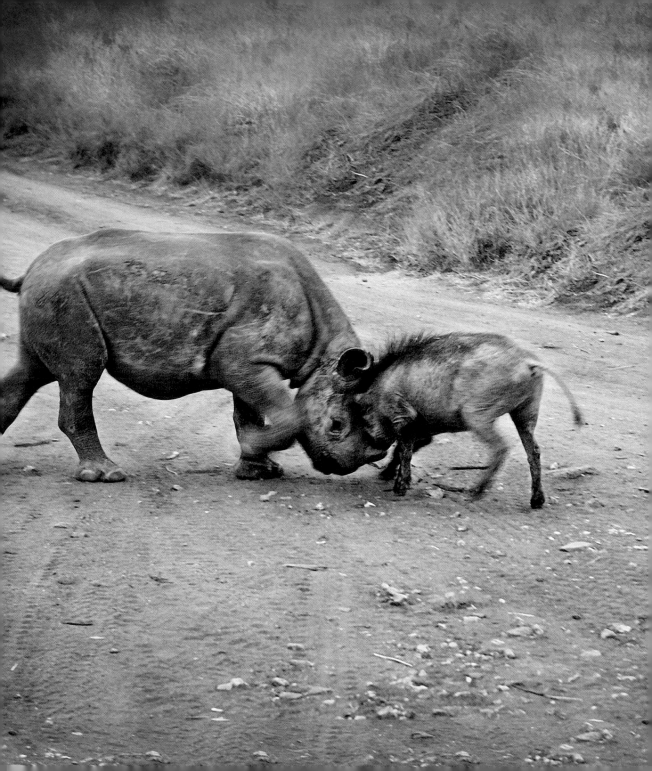

The Black Rhinoceros *and the* Warthog

SOMETIMES LOVE MEANS JUST BEING THERE FOR SOME-one else. *All the time.* And it may also involve a bit of grooming. I'm not referring to a gentle hair brushing or face washing. In a wild animal park in Kenya, it can mean picking dozens of ticks out of skin folds and, well, eating them.

Hey, don't cringe! Life in the wild requires coping with all sorts of unpleasant things. And even a blood-sucking arachnid is a perfectly nutritious food for some animals out there. (For the record, around the world a lot of people, too, eat insects, spiders,

WARTHOG

KINGDOM: Animalia
PHYLUM: Chordata
CLASS: Mammalia
ORDER: Artiodactyla
FAMILY: Suidae
GENUS: *Phacochoerus*
SPECIES:
Phacochoerus africanus

and the like, though ticks, I suspect, aren't typically on the menu.) The tick-related grooming/feeding task in this tale fell to Digby, a warthog, whose relationship with a black rhino named Omni went above and beyond what you or I might call friendship. After all, when was the last time you plucked parasites off your neighbor or school pal, and did it with gusto? Exactly.

Despite the ticks, this is an endearing love story, and it involves not just the closeness between rhino and warthog but between rhino and his keepers, too.

Late in 1999, a blind black rhino named Mawingu, at the Lewa Wildlife Conservancy in central Kenya, gave birth. The male newborn was named Omni. He was hand-raised, to give him a better chance of survival than an older sibling that didn't make it, and it paid off. Black rhinos are critically endangered, so each life is especially precious. The Lewa sanctuary is one of the few places that successfully breeds and raises the animals to help increase their numbers. Omni is part of that success.

At just a few days of age, Omni met Digby, an orphan warthog also needing human care. "It is difficult to describe their first meeting," Omni's keepers told me, "because they have been together since the beginning!" With their ages so close and neither having their mother caring for them, the two were kept in one bed like twins, albeit without the resemblance. Being out of their wild element, "they were isolated from their own kinds," say the keepers. "So they formed a

close bond with each other." In fact, anyone peeking into Omni's night pen would have glimpsed a single blanketed mound that was a baby warthog atop a baby rhino, both fast asleep.

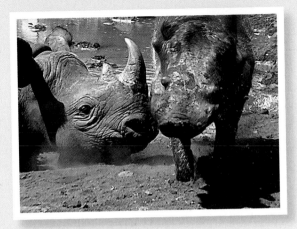

As they grew, it was clear that Omni was mild in temper, a real softy. Digby became a little more moody, as warthogs are prone to be. Yet "they rarely had angry moments," the keepers recall. Instead, they were sweet to each other, "licking and pushing playfully, running around like delightful kids!" And, of course, there was the grooming. "Digby was so persistent when it came to getting rid of Omni's ticks!" Indeed, a film shot by the BBC at Lewa shows Digby nosing Omni's ears in search of munchies and digging with his snout into the rhino's cracked and creviced skin, with Omni lying in the dirt, perfectly content.

But Digby wasn't always looking for a physical reward from Omni. The keepers say they were together all the time, whether eating, playing, walking through the bush, or wallowing in mud puddles to cool down. "The two were very protective of each other, and would try to scare off anyone who might be a threat to the other. They were brothers, best friends, and keepers of each other. They loved each other like family."

Meanwhile, the keepers themselves established a very special bond with Omni. Legei, in particular, loved the rhino, having been

BLACK RHINOCEROS

KINGDOM: Animalia
PHYLUM: Chordata
CLASS: Mammalia
ORDER: Perissodactyla
FAMILY: Rhinocerotidae
GENUS: *Diceros*
SPECIES: *Diceros bicornis*

the first one to care for him, bottle feeding him four times a day, taking him for walks, and helping Digby with that all-important grooming—scraping parasites from Omni's skin. For Legei, as for Dibgy, Omni would lie down and happily, calmly, let the cleaning take place. It was a massage and a bath all at once . . . how could he resist?

"I was both mother and father to these animals," says Legei. Especially to Omni. Starting at the tender age of nine days, Omni knew no other parent than this young man. "I would wake up in the middle of the night to feed and cover him." Omni and Digby shared a bed made of grass, and keepers Kaparo and Kisio also spent time living with the animals to help Legei with their care. The men sang to the orphans—like parents to their babies.

Eventually, in 2002, the animals were to be relocated to another park about 24 miles away, and the keepers planned to walk them all the way there. Omni, who had become the leader of the two, was ready and willing to make the journey. But Digby didn't want to leave his first home, and partway there hunkered down and refused to move, even when Omni coaxed him along. He finally turned and ran back, and the keepers and the rhino had to continue on without him.

Back at home, Digby was clearly devastated that Omni was no longer there. He searched relentlessly, then went on a destructive rampage when he couldn't find the rhino he loved. The keepers soon realized that the animals needed each other, and decided to try to reunite them by flying Digby to the new location. But sadly upon

arrival, the confused warthog ran off, disappearing into the wildlands, never to be seen again.

Was it love between rhino and warthog? According to Kaparo, when the two were together they were like a new couple, always touching, licking, or "petting" each other with snouts. They were there for each other for many years, no matter what the circumstances. And Digby's behavior after their separation resembles that of a heartbroken teen, breaking rules and running away.

Sadly, I must report that Omni recently died at the hands of poachers. Legei and the others felt a special love for Omni and are devastated by the loss. Before his passing, they visited him whenever they could. And Omni remembered those who cared for him all those years, especially when he heard their voices. Poaching of African wildlife—for food or, often, for valuable animal parts like horns—takes a huge toll. Rhinos have been hit particularly hard and their numbers are dwindling. Omni is one tragic loss of many.

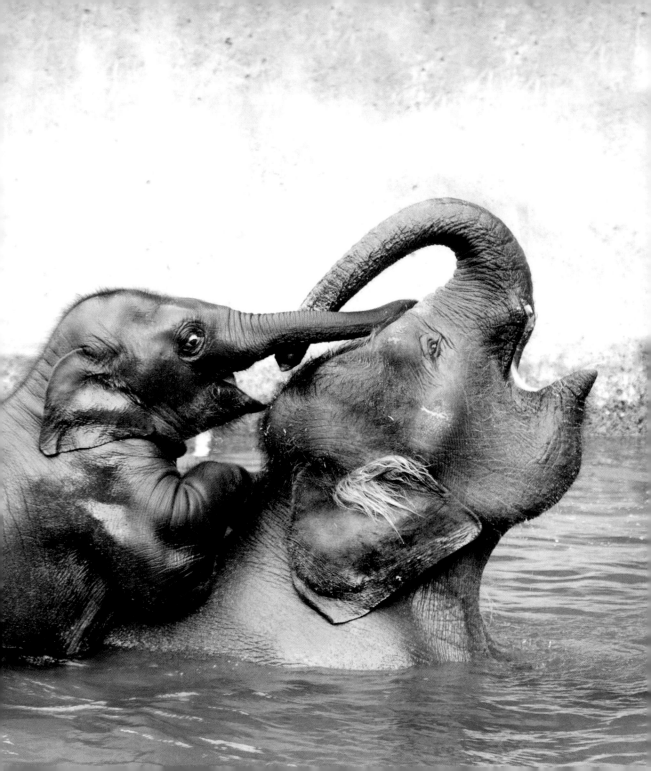

The Elephant
and the
Zoo Friends

ON THE INDONESIAN ISLAND OF BORNEO, LIKE IN MANY far-flung parts of the world, the line between human and wild is becoming razor-thin. Where industries and economies are growing, nature often cowers under the strain. And some of the fast-expanding industries put the heaviest weight on wildlife.

More than a decade ago, a young elephant named Chendra lost her world and her wild companions to such human enterprises. But then, thankfully, humans endeavored to give life back to her. Hers is an unlikely love story of a very special kind.

ASIAN ELEPHANT

KINGDOM: Animalia
PHYLUM: Chordata
CLASS: Mammalia
ORDER: Proboscidea
FAMILY: Elephantidae
GENUS: *Elephas*
SPECIES: *Elephas maximus*

It's not an uncommon scenario these days: When the forested area of Borneo where Chendra was born was laid bare and converted to commercial plantations for the palm-oil industry, thousands of animals were displaced, injured, or killed. Having survived a shotgun wound that blinded her left eye and then weeks chained up at an Indonesian rehab center, Chendra was actually luckier than most. While still just a calf, word came that there was space for her at the Oregon Zoo in Portland.

"She couldn't be released in Borneo because she wouldn't have survived on her own," says Bob Lee, the zoo's elephant curator. She didn't have a herd, other elephants that would take care of her. "So we were happy to take her in."

Elephants, you see, need each other. They are exceptionally social animals, especially the females, remaining in family groups (with a matriarchal leader) their entire lives. The bond between pachyderms is knot-tight (they even mourn their dead in familiar ways), and physical touch is one key way they show loyalty and affection within the herd.

So once in Oregon, Chendra was given access to other elephants, to become part of a group, touching and communicating like she would in the wild. "We let her become very connected to the herd here," Bob explains. "We exposed her to males, and she witnessed elephant births and has befriended the babies—one used to crawl up on her back in the pool when they played together."

Putting Chendra among elephants was vital to her recovery from her traumatic beginning, but that wasn't the only way to enrich her life. "We wanted more activities, more ways to feed her curiosity," Bob says. And because in the wild, elephants are just one of many residents, "we started walking her around the zoo to meet the other animals. She's like a well-trained dog—she'll stay right with us. We can also let her go for a bit, keeping a wide circle around her, and call her back if she gets too far away." Those baby elephant walks became social hours for Chendra; the sights, sounds, and smells of other creatures intrigued her, and she found out that making friends isn't an act confined to the elephant habitat.

"She wanted to see everything, to meet everyone," Bob says. "She's so inquisitive, and the other animals were interested in her, too. She'd sniff the air, flutter her ears at the squawks and squeals and shrieks from the other habitats as the animals called out to her. She'd inspect whatever she could reach with her sensitive trunk." The sea lions, for example, would circle around her as if she were the guest of honor at a party. Soon, Bob says, "She was reaching out with her trunk to try to sniff them through the glass. And when we'd go back another day, she'd make soft noises, little rumblings, when she first saw them. Happy rumblings."

PALM OIL

Indonesia is one of the largest producers of palm oil, used in food, consumer products, and biofuel. Unfortunately, the industry is responsible for wiping out massive tracts of rain forest. Consumers who seek palm oil–free products or products with the certified sustainable palm oil label are helping protect wild lands and the animals they support.

♥

Today Chendra's friendly gestures reach all around the zoo, from the sea lions and penguins to the goats in the petting area. "One goat in particular has a crush on Chendra," Bob says. "Every time we walk by he runs up and climbs on the fence, trying to be nearer to her. He bellows out, she sniffs him, and then they just hang out together for a few minutes before we move on. It's obvious they like each other."

But the biggest love story may be the one between Chendra and the people who have been such an integral part of her healing. Bob has worked with elephants for more than seventeen years, but Chendra holds a special place in his heart. "She's really like our kid here at the zoo," he says. "We watched her grow from a tiny nervous orphan girl to a grown-up adult, a confident 'woman,' if I may. The staff is here seven days a week plus holidays, so we see her, interact with her, every day. We've become her family and she is ours. For us it is truly love, there's no other way to say it."

And in the morning when Chendra sees Bob or her other human family members, "she runs over making those rumbling noises, sniffing and touching, showing off how sweet she can be." The connection definitely goes both ways, he says, people to elephant and elephant to people. "There may be nothing more rewarding than that."

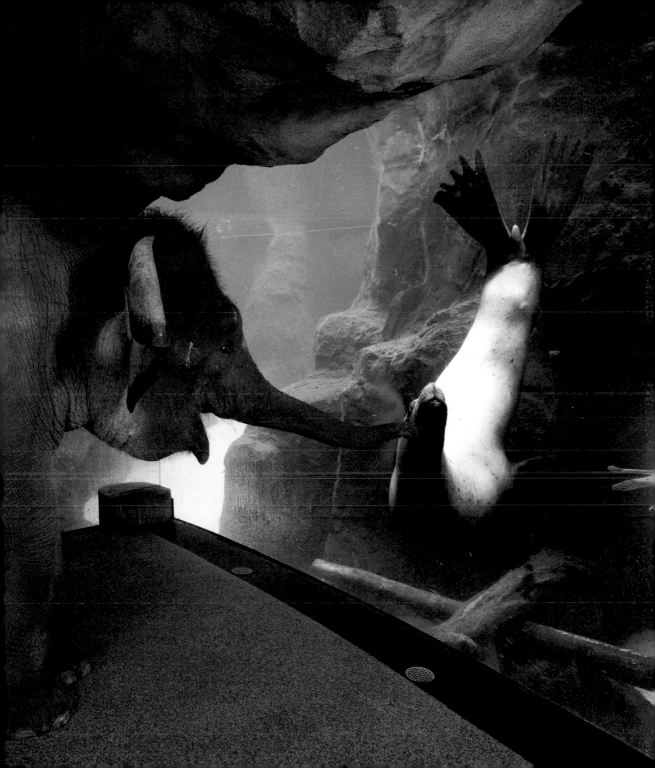

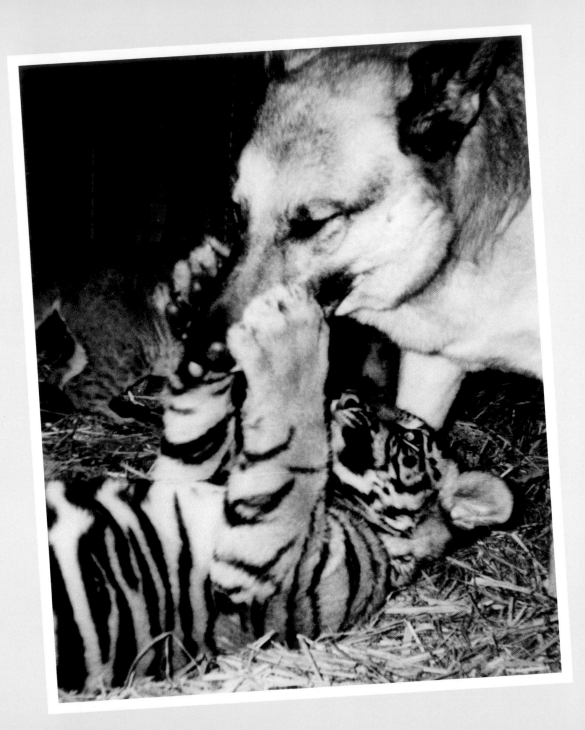

The Lady, the Tiger, and the German Shepherd

ANYONE WATCHING **S**ARAH **H**ARRISS APPROACH THE CAGE of an old Bengal tiger, clicking her tongue and speaking his name, might have worried for her safety. But there was nothing to fear. The eighteen-year-old tiger chuffed a reply, rushing over to greet her. He rubbed against her through the bars and she reached through to stroke his giant head and neck. If a cat can love, this is how it must look.

Sarah has had an exceptional bond with Bruno the Bengal for most of his life. He had been rescued from a circus

BENGAL TIGER

KINGDOM: Animalia
PHYLUM: Chordata
CLASS: Mammalia
ORDER: Carnivora
FAMILY: Felidae
GENUS: *Panthera*
SPECIES: *Panthera tigris*
SUBSPECIES: *Panthera tigris tigris*

as a five-week-old kitten and taken to Paradise Park in Broxbourne, Hertfordshire, England, where Sarah lived and worked, and she was responsible for his care. But even more remarkable than the lady–tiger relationship was the one that bloomed between the big cat and Sarah's German shepherd Cash.

Except sometimes as pets in the home, cats and dogs don't usually find common ground. But starting in 1994, Bruno and Cash were the exception to the rule. In Sarah's daily rounds at the park, she was responsible for feeding a number of feline orphans, including a litter of lion cubs and the young tiger. And Cash, always by her side, got to know them, too. "He was wary at first," she recalls, "as he should have been—that's only natural."

But eventually he started interacting with all of them. "He would give them a whack if they scratched him but otherwise he was so gentle, licking their muzzles and bums. He acted like their mother." As the animals grew up and spent more time in an outdoor enclosure, something special brewed between Cash and Bruno. "Bruno and Cash treated each other differently than they did the others. They'd play independent of everyone—one would roll over and the other would run up and start wrestling, they'd play tag, they'd snuggle up together. We'd take Bruno on walks around the zoo and Cash would come along. One time some llamas got too close, and Cash nudged them away," as if protecting his friend from strangers (or maybe not wanting to share). "The way they acted," says Sarah, "the way they stopped and looked

at each other, it was clear they totally loved each other."

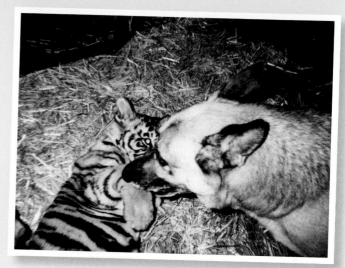

Sarah says Cash, as a puppy, had been a very nervous dog. "But when he was with Bruno, he was in another domain—he was a different animal. Seeing him find himself and be fearless and dominant was lovely. Bruno brought that strength out in him."

Tiger and dog were playmates for more than eight months, but eventually the tiger's size and boisterousness was too much for Cash—Sarah worried he might get hurt. So, playdates ceased and the animals could see each other only with a barrier between them. But Sarah is sure their friendship remained at the ready, in case they were reunited.

Eventually, Sarah left Paradise Park, and Cash passed away back in 2001. "But he spent the rest of his days doing things for other animals," Sarah says. "That's just the kind of dog he was."

And Bruno? He has since retired from public view, moving to another animal facility in Kent, where Sarah visits him from time to time. "It all comes flooding back when I see him," she says, "how I used to lie in the cage and have lion and tiger cubs crawling all over me, and how Cash and Bruno played and wrestled and loved each other. I was so lucky to be part of that."

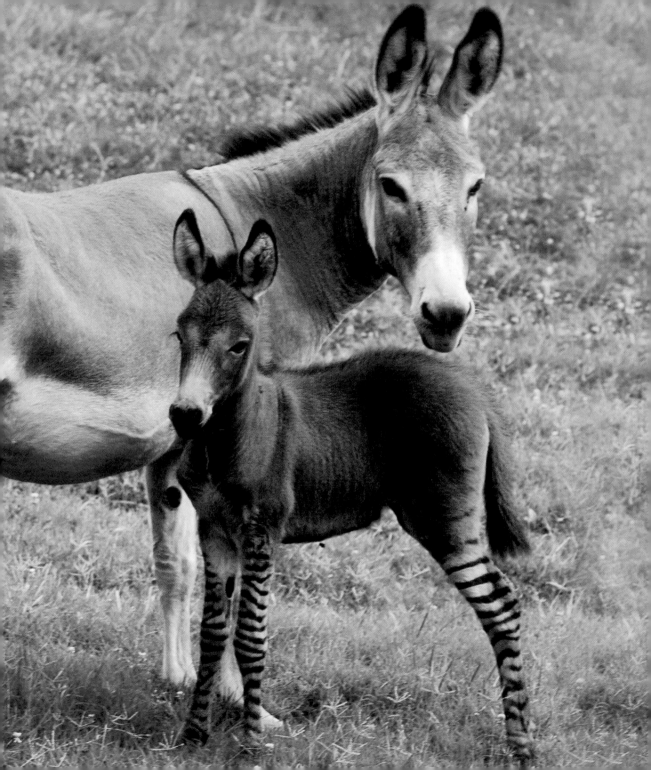

The Zebra and the Donkey

NOW FOR SOMETHING COMPLETELY DIFFERENT, LET'S hear about the zebra that loved the donkey—at least twice. We'll call it a two-night stand. Wonderfully, the unexpected affair resulted in two very rare and precious gifts.

Zeke the zebra and Sarah the donkey had been running in the pasture together without incident for years. Both live at the Chestatee Wildlife Preserve in Georgia, run by founder C. W. Wathen, pronounced with the appropriate Southern drawl as "cee dubya."

Zebras are naturally a bit skittish. And for good reason. In the wilds of Africa, chances are a big cat predator is lurking in the grass. Smartly, the ungulates tend to hang out with herds of

wildebeest or Cape buffalo, seeking safety in numbers. And though to us they seem to stand out, zebra stripes may actually offer them some camouflage in their natural savannah habitat.

Anyway, here you have Zeke living among the other pasture-going animals, the horses and cows and donkeys. ("It's a real zoo around here," C. W. jokes.) The donkeys in particular seem to keep the zebra calm. "I've run them together for years," he says. "Everyone gets along great and the zebra stays settled." None of the animals has ever shown another any particular affection, he says—there's no nuzzling or courting or sneaking off to cuddle up, at least not that he's witnessed.

And yet, some particular affection *did* happen. And the only reason C. W. found out about it was because suddenly, his donkey

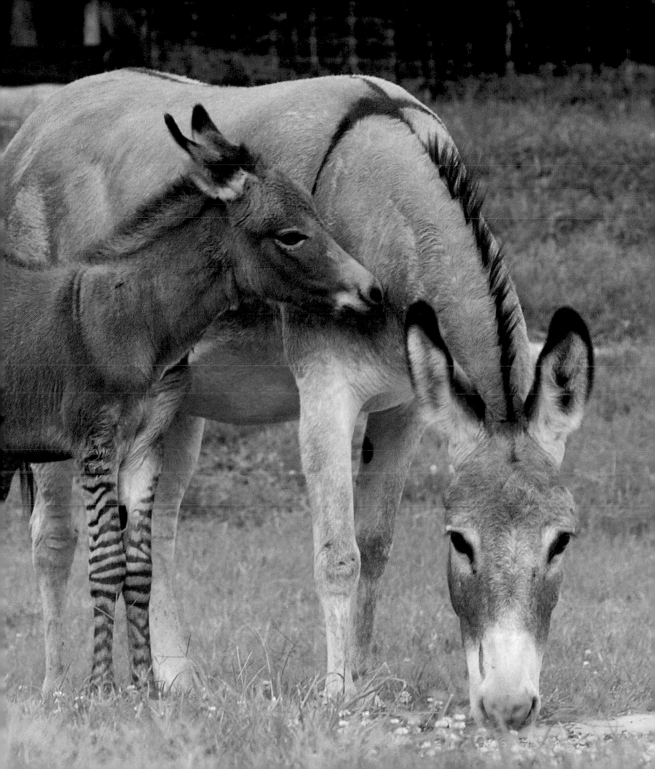

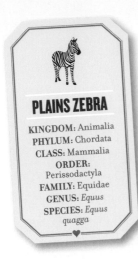

PLAINS ZEBRA

KINGDOM: Animalia
PHYLUM: Chordata
CLASS: Mammalia
ORDER:
Perissodactyla
FAMILY: Equidae
GENUS: *Equus*
SPECIES: *Equus
quagga*

Sarah was pregnant. And some twelve months later, out dropped a creature that was a little bit donkey and a little bit zebra, which kind of gave things away.

"We only have one male zebra," C. W. says, "so we know he's the one. He can't hide from that!" Still, he says, around the barnyard, "nobody's talking."

So now there was Tippy the "zedonk," a bit wobbly at first, as newborn ungulates are, but soon running with the long-legged crowd. Her own legs appear dressed in striped tights (from Dad); her long face is a good mix; her ears are Mom all the way.

Zedonks and similar critters are happy rarities, reported now and then at zoos around the world. A British zoo announced recently the birth of Zulu, their first "zorse." (Dad, obviously, was a horse.) There are also "zonkies," when the dad is the donkey and the mom, the zebra. Whatever the name, zebra blood flows through all of their veins.

So with Tippy trotting about, C. W. figured it was back to business as usual. But then, another cross-breeding surprise. "It happened again!" C. W. says. "We didn't plan it! In fact, we were going to send Zeke away to breed him with other zebras, but people who visited the preserve wanted to see Tippy with both parents. So we delayed the loan." And that bit of extra time together was all they needed. Zeke and Sarah, in the hush of a barnyard night, mated for a second time. And soon, there was Pippa. Striped stockings, long face. Sister to Tippy.

Zedonk zedonk.

So, two zedonks now steal the show at the Chestatee Wildlife Preserve. "They're so personable. They always go right up to the fence when people come to see them," C. W. says. They have the alertness of a zebra—ears perked, listening for danger, yet they are calm like their donkey mom, he says. And the wacky sound they make: It's not quite a donkey bray and not quite a zebra holler, he says. "Something half and half. My wife and I wonder if the mom even understands them, but she must because she's always right there when they cry." Though Zeke has since been shipped elsewhere—he's on breeding loan at an Alabama zoo to make more zebras, of all things—his legacy at Chestatee is perfectly sweet, if not perfectly customary.

"There are people who put lions and tigers together, to make ligers," C. W. says. "There are wallabies and kangaroos—walleroos? I didn't plan to mix things up here, but this is real life and things happen." And he's not unhappy with the result, of course, including the herds of visitors coming to peer at the baby ungulates in brown coats and striped socks. Says C. W., "Some people just have to see for themselves that they're real."

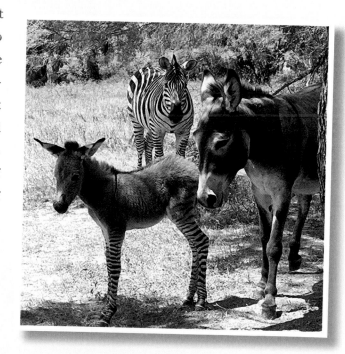

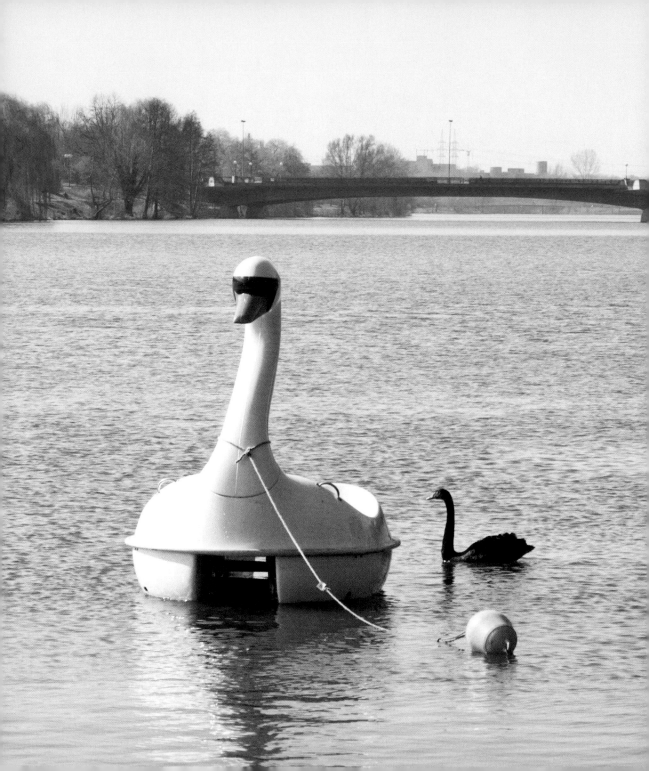

The Swan and the Swan Boat

LOVE COMES IN ALL COLORS, SHAPES, AND SIZES. AND materials, apparently. If your heart is truly open, even plastic is worthy of deep affection.

The lovable plastic in this tale was a boat. The one who fancied that plastic was a bird. This is their story.

Petra, a black swan, showed up in a lake called Aasee in Münster, Germany, some years back. On that lake, it so happened, sat a white paddleboat, the type visitors use to enjoy a sunny afternoon on the water, propelling themselves this way and that. For Petra, one look at the boat was all it took. She was a swan's version of smitten.

Before we all smirk at Petra's battiness, we should appreciate the bird's-eye view. The boat, after all, was shaped like a swan

BLACK SWAN

KINGDOM: Animalia
PHYLUM: Chordata
CLASS: Aves
ORDER: Anseriformes
FAMILY: Anatidae
GENUS: *Cygnus*
SPECIES: *Cygnus atratus*

and floated in a very swanlike fashion. It wasn't the most responsive partner one could ask for, and was a giant compared to live swans. But maybe Petra wasn't one for idle bird chatter, and felt safe in the shadow of an extra-large mate. Whatever her thoughts, she was clearly drawn to the towering, featherless figure stuck in swan-on-a-lake position. She began to follow it around, and for a time the couple seemed perfectly content.

This floating love affair got a lot of attention, of course. Everyone wanted a glimpse of the lovebirds swimming side by side, as mated swans will do. Interest in the pair reached its peak when it came time to put the boat away in storage for the winter. "The question was, how would Petra deal with the loss of her plastic lover?" says Ilona Zühlke, of the nearby Allwetterzoo Münster animal park, who shared this story with me.

With all the happy hubbub over the pair, the zoo's officials agreed to take both swans in for the cold season. It took a week of careful traveling to get both bird and lover into their new home, but the trip was a success and Petra and her boat spent a relaxed winter together.

When spring came, the animal caretakers thought it best to introduce Petra to other real swans. A plastic mate might be good company, but there was little chance of their building a family. So Petra and the boat were moved to a pond where six other black swans lived. Briefly, there was scandal: One of the unmated females in the flock fancied the white paddleboat (who seemed unmoved by her advances), while the

other swans fancied attacking Petra. Quickly, realizing their experiment had failed, the zoo staff took action to protect Petra from injury. She and her boat would be moved one last time—back to the Aasee where they'd first met.

Like a man being groomed for his wedding, the swan boat was cleaned, repaired, and oiled before the big day when it would be towed by motorboat down the canal that leads to the lake at the city center. Petra, like a bride escorted by her father, rode in the front boat in the arms of the director of the zoo, Jörg Adler. Countless spectators on foot, on bikes, and in other paddleboats brought up the rear, anxious to see the reunion.

And when Jörg finally placed Petra in the water with her big plastic mate bobbing beside her, the crowd cheered. Petra then stretched her wings and preened her feathers, recalls Ilona. "We could tell she was happy to be home again."

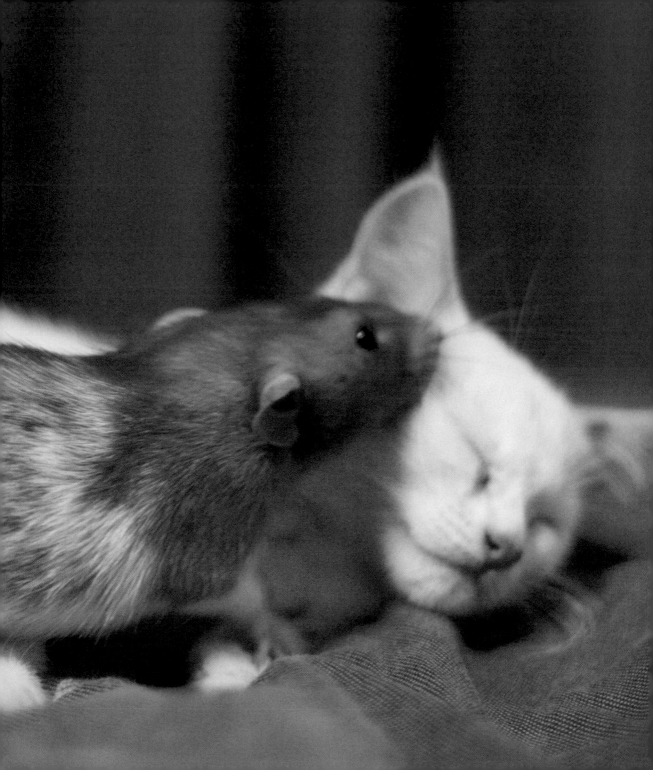

The Rat and the Kitten

WHO DOESN'T LOVE TO NUZZLE WITH A KITTEN? I CAN'T say the same thing about a rat. More people are likely to shriek at the sight than open their arms to a rodent.

Let's clear our minds of such judgments and give rats a fresh start. They're smart, playful, even ticklish. They'll cuddle with you if you let them. I'm not suggesting you trap one from the back alley and tuck it into your bed. (By no fault of their own, city rats can spread disease.) But the "fancy" types are bred to be pets.

Maybe Aiden can help make my point. Aiden the rat belongs to Texan Lance Clifton, a website developer and a repeat rat owner. Before buying Aiden, Lance had Lemmi and Spencer living as a pair, but sadly, Lemmi passed away after a stroke. "I wasn't actually

BROWN RAT

KINGDOM: Animalia
PHYLUM: Chordata
CLASS: Mammalia
ORDER: Rodentia
FAMILY: Muridae
GENUS: *Rattus*
SPECIES: *Rattus norvegicus*

planning to get a new rat the day I saw Aiden," Lance says. "I had gone to the pet store to get food and bedding for Spencer, and walking by the rodents I saw a nicely colored 'dumbo rat,' a special type that's bred to have big ears." He asked the shopkeeper if he could hold the animal (which, deep down, he knew would likely clinch the deal). The rat reacted just right—not squirming and trying to escape but curiously sniffing and inspecting him.

Sold.

Lance isn't fond only of nontraditional pets; he's easily won over by the typical ones, too. Shortly after getting Aiden, a friend of Lance's mother announced that she knew of some stray kittens—beautiful Siamese mixes—needing homes. So, home came Tessie.

"Tessie was very docile and I didn't think she'd be much of a threat to the rat," Lance says. "So I decided to place them on my bed together and see what would happen."

What happened, he recalls, is that Aiden ran for the rather confused kitten without hesitation. "He wasn't being aggressive. It was unlike the initial introduction to his cage-mate [Spencer], when he raised up his fur and slapped his tail. Instead he was immediately interested and happy to interact."

When the kitten walked away, the rat followed. And when she lay down, Aiden sidled up next to her and started grooming her. Apparently, that felt good: "Tessie didn't walk away after that," Lance says. "She accepted the gesture, hugged him, and fell asleep."

"Grooming for rats is a very important social gesture—a 'we're family' statement." Each gets a turn, and they'll nudge each other for help getting at those hard-to-reach spots behind the ears. During the rat–cat encounters, each animal "purred" in its own way. For a few weeks, Lance put the animals together regularly, letting their affection for each other grow. He would stay nearby to supervise, but mostly he trusted they wouldn't harm each other.

Sometimes family members change and go their own ways, and that eventually happened with these two. Tessie got bigger and her teeth and claws sharper, and her play behavior went from gentle to, well, tooth and claw. "So for now I keep them separated," Lance says. There's nothing malicious about it, but he wants to protect Aiden from the cat's overzealous affection while she's in this adolescent stage.

But even without direct contact, Aiden and Tessie have kept up their affiliation. "Often Tessie will lie on top of the rat's cage, and Aiden will run over and put his nose up to her, like he's saying hello," says Lance. He's hopeful that eventually Tessie will mellow out. "Then I can reunite them without the bars."

The Lioness
and the Lioness

JEALOUSY ISN'T PRETTY. WE'VE ALL SEEN IT OR FELT IT
ourselves, often over silly things. But it's a complex emotion.
And it's not one you'd expect would infect nonhuman animals.

Yet here we have a lioness who, it certainly seems, is so pos-
sessive of her best friend that she refuses to share, and gets jealous
if that friend shows affection to others.

The deep affection between lionesses Achee and Ma Juah arose
at a sanctuary of the Born Free Foundation within Shamwari Game
Reserve in Eastern Cape, South Africa. Born Free has taken in
many homeless big cats, making sure to prevent breeding so as
not to add to the captive cat population when there are so many
animals in need.

And anyway, in the case of these two felines, offering mates wasn't an option: Both were suffering the effects of nutritional osteodystrophy—abnormal skeletal formation and nerve damage resulting from a poor early diet. The condition had produced a bizarre gait and a head-shaking behavior in the females that to a male could signal weakness and might prompt him to attack rather than mate.

"Fortunately, and coincidentally," says Ann Tudor of Born Free, "we were called on to rescue Ma Juah and Achee within weeks of each other." Ma Juah came from Liberia, where she'd belonged to a former dictator, and Achee from Romania, the pampered pet of a European consul. Because companionship is so vital for lions, "we decided to attempt to bring the two together. Otherwise, each would be destined to a life of solitude."

It's important to mention that introducing two unrelated lionesses is tricky. In the wild, only cats that are true family would get along.

At first, Ma Juah hated Achee and would snarl at her and attempt to swipe her. Such stress brought on little fits in the irritable cat, probably also a result of the poor nutrition during her upbringing, and Ma Juah would fall over from her own aggressive efforts.

Achee accepted this strange behavior in her friend. According to Glen Vena, Shamwari's animal care manager, "Another lion might recognize this as unnatural and so might instinctively attack. Instead, on some occasions, Achee would groom Ma Juah and sometimes even give Ma Juah a push with her head, as if to say 'get up, girl.'" He adds that if this happens during feeding, "Achee will never run off

with Ma Juah's food, which is quite amazing. Ma Juah must sense she is at a disadvantage at this time, so this nonaggressive response from Achee must be a comfort to her."

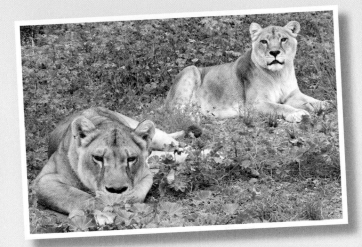

That comfort may have helped Ma Juah to change her opinion of Achee, and as the weeks went by, her cold demeanor began to thaw. In fact, soon Ma Juah wanted Achee all to herself!

As a result, now Ma Juah and Achee act like loving sisters or a couple you probably know: They are rarely seen more than a few feet from each other; they bump hips as they walk; they nose each other, share food, and lie in tandem—sometimes with tails intertwined "as if they just want to be touching each other," says Glen. And if they've been apart, when they meet again they rub heads and make affectionate meowing sounds.

Achee remains friendly with people and with a little male lion, Sinbad, living next door, but if she pays attention to anyone else for more than a moment, Ma Juah shows her green side, snarling and growling in the background until her Achee returns to her.

Accepting the possessive love from her former aggressor, Achee always rejoins Ma Juah directly, and the two walk off together, shoulder to shoulder, solo no more.

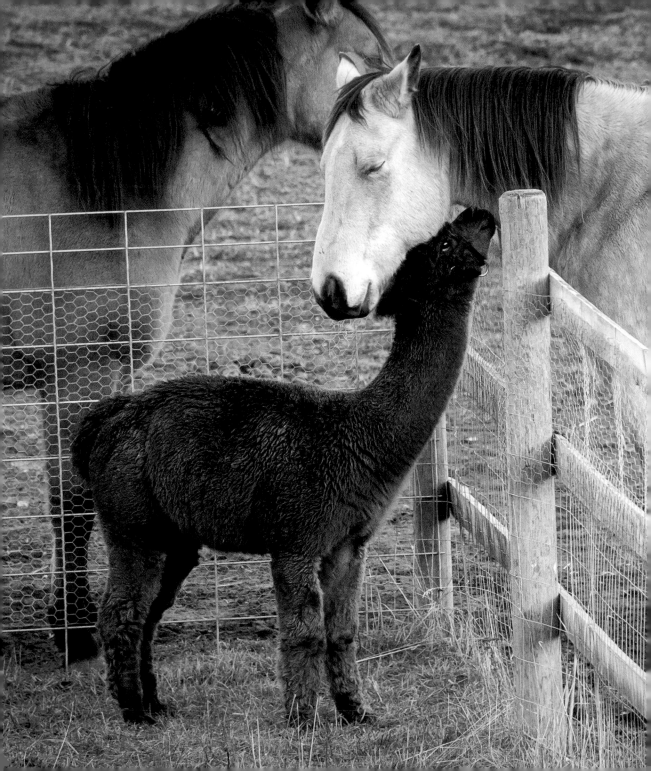

The Alpaca *and the* Horses

HAVE YOU STOOD BENEATH THE BIG SKY OUT IN THE western United States? If not, make the trip. Even if you don't experience any cute interspecies interactions against that backdrop, you'll be invigorated by a landscape that lets you see for miles and breathe deeply of its vast, airy beauty.

That sense of freshness, of openness, is what drew a New Jersey woman to Montana a few years back. Living in Bigfork, at the base of the Rockies, Lauren Grabelle took a turn at the rural life and, to her good fortune, watched a sweet interspecies fondness grow right outside her door.

"The first time, it was a gorgeous day, that glowing time of the afternoon, and the sun was about to do awesome things on

ALPACA

KINGDOM: Animalia
PHYLUM: Chordata
CLASS: Mammalia
ORDER: Artiodactyla
FAMILY: Camelidae
GENUS: *Vicugna*
SPECIES: *Vicugna pacos*

the mountains," Lauren recalls. "It's like that in Montana: suddenly perfect." She was staying in the upstairs of a barn on a beautiful property at the time, making her living as a wedding photographer. "Which means I'm always on the lookout for love," she says. But here, with the Swan Range in the distance, the land and its resident animals—horses, dogs, alpacas—inspired her as much as the couples who hired her to record their special day.

Now, it wasn't all sunshine and rainbows for Lauren. While her location inspired her, she felt no love for the woman next door, who owned the apartment Lauren rented and the animals in the barn below. "She thought she was an animal person, but she wasn't," Lauren recalls. "The animals didn't like her, either."

And so Lauren sought refuge in the nonhuman living things within her view. And on that sun-kissed afternoon, as she returned to the barn from a walk with her dog, she observed a charming moment that completely surprised her.

"The alpacas had just been moved there, to join the horses, a week or so before," she recalls, "so I hadn't had much time to watch them yet. There were two females, Mango and Whispy, plus a male named Rocket Man. As I went up the stairs to my apartment, I noticed that Rocket Man was nuzzling two of the horses. He didn't seem to just be scratching an itch—it really looked affectionate. It seemed to me they were getting to know each other through touch and smell."

Alpacas, originally from South America, are social animals, hanging with the herd, and can be territorial toward animals unlike themselves. That can mean short, loud inhalations of warning or even spitting, kicking attacks.

But there was none of that aggression toward the horses in the yard. Just the opposite, in fact. These different animals were interested in each other, and their behavior suggested a connection building across species lines.

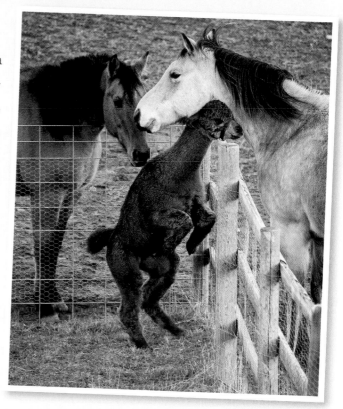

The relationship between the animals seemed to grow over time, and on another day Lauren caught alpaca Rocket Man "in a love fest" with horse Luis. The photographer went to work, thrilled at the scene before her and at the kindness the animals seemed capable of sharing.

"This was the reason I was here in the first place," Lauren says of these encounters. "The reprieve from everything negative that these animals offered me was enormous. Whenever I got up from my desk, this is what I saw, these beautiful animals getting along, nuzzling as

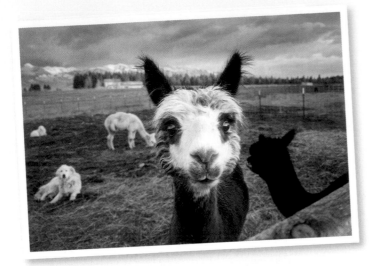

if in love. I was feeling very apart from nature when I was back in New Jersey, and I had lost my fascination with people. Being so close to the horses and alpacas was really special."

No doubt many of us have been soothed by animal kindness when our hearts are feeling hardened. Lauren was just lucky to find her remedy right outside her door.

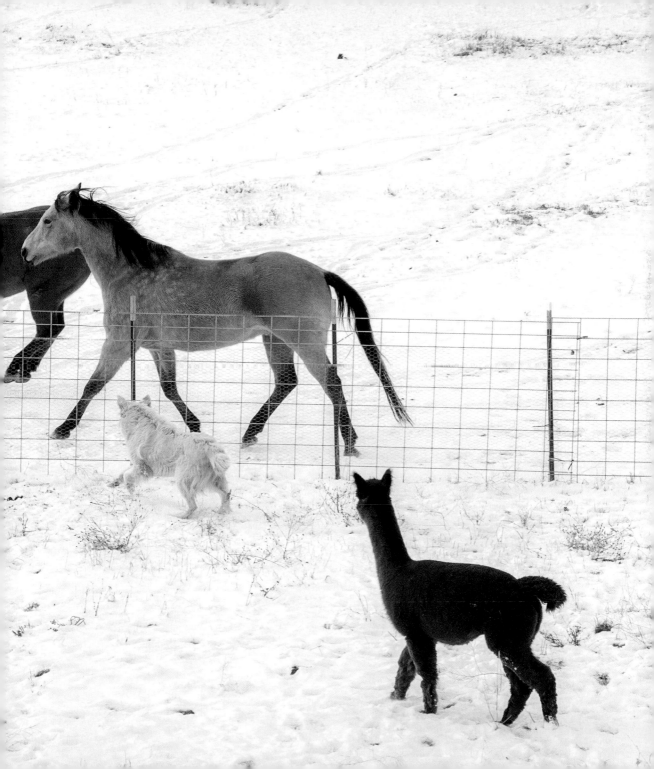

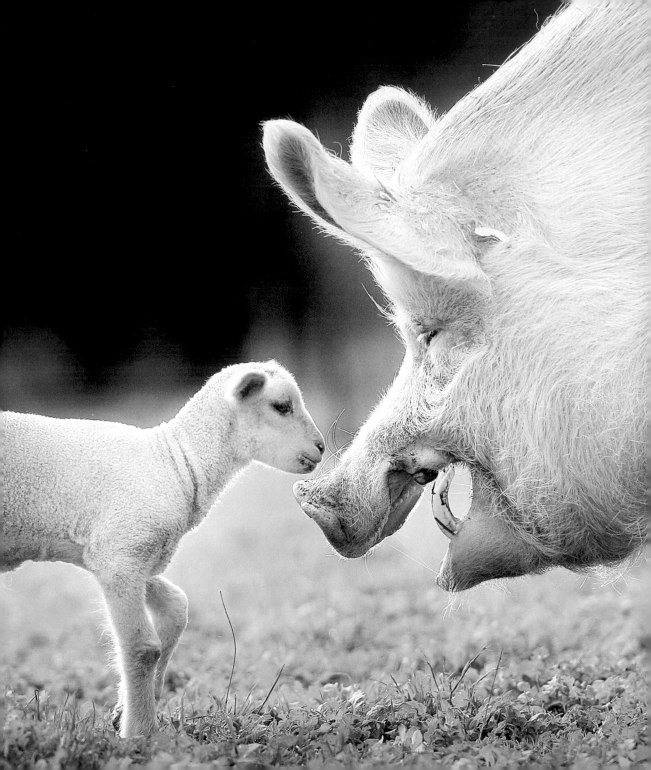

The Pig and the Farm Pals

WHEN I WAS A KID, MY FAVORITE BOOK WAS *CHARLOTTE'S Web*. In that classic tale, the spider weaves in her web the words "Some Pig," a silk billboard to let everyone know how special her porcine friend Wilbur is. Well, here's another mud wallower that could pose under those words with pride. Meet Edgar.

"If it weren't for Edgar, none of this would be. I'm just so grateful he found me."

Those words of appreciation come from Pam Ahern, who founded Edgar's Mission Farm Sanctuary in Willowmavin, a tiny town in central Victoria, Australia. And she did so to honor her relationship with a dirt-loving, curly-tailed, snorting beast. Edgar Alan Pig, as he was formally known, turned out to be the lovable muse that changed her life for the better.

Pam had been working on a media campaign about the plight of factory-farmed pigs, horrified by the conditions under which they lived. To show her solidarity with the animals, and because she needed a pig for a campaign photo shoot, she decided to bring one home—to save its bacon, as it were. "We had the land and I knew about pigs, so I figured, why not," she says.

Pam recalls the day she rescued Edgar and took him home to pose for the camera. From his time on the factory farm, "he was covered in excrement. He really stank." Pam and her mother, Sylvia, wrestled the smelly swine into a tub for a bath as compassionately as they could. "He didn't want anything to do with me, not surprisingly. But fortunately, he fell in love with my dog, E. T. That's how things started."

"When they were in the yard, Edgar followed E. T. everywhere," Pam says. It was a relief for her, especially on photo shoot day. "Because I had E. T. with me on a lead the whole time, Edgar stuck by. He followed E. T. and E. T. followed me."

It worked in public, too. "We'd go walking at our local park and people came from everywhere to see Edgar. 'Wow! A pig on a lead,' they would enthuse," Pam says. "He'd roll over and let people rub his belly, grunting with happiness." And having Edgar draw a crowd gave Pam an audience for her campaign. "Normally if you have a petition you want people to sign, they try to get away from you. But with Edgar there, people came right over to see what we were doing. Edgar allowed their hearts to do the talking—and it was clear they were listening, too." After meeting Edgar and chatting with Pam, she says, "many walked

away with a newfound appreciation of and even love for farm animals."

It was only because Edgar liked E. T. so much, Pam says, that the pig eventually learned to like her, too. "I guess he figured that if E. T. thought I was okay, he'd give me a go. I was really touched when he began to trust me." And eventually, with her inspirational pig on a leash beside her, Edgar's Mission came to be. "I wanted to give refuge to animals like Edgar, to give voice to both the ones we could save and the ones we couldn't," she explains.

Once the mission was established on the farm where Pam lived, she quickly collected a host of creatures needing asylum. Edgar had his favorites, but otherwise he was a pretty solitary guy. Oddly, he wanted nothing to do with the other pigs on the property. "All the other pigs were buddies with each other, but he'd run screaming from them," says Pam. There was even a female, Alice, who liked him, to no avail.

"She'd chase him around, grunting, and he'd hide in the straw as if maybe if he stayed really still she wouldn't know he was there." Pam says whenever Alice got wind of Edgar, "He would run from her as fast as his fat little legs would carry him!"

In addition to E. T., Edgar seemed smitten with a little sheep, Arnie, who had been attacked by a fox. "Edgar would get in Arnie's bed and sleep alongside him. He really looked after him," says Pam. There was a goat, too, who won Edgar's friendship. All three would hang out together, the sedentary Edgar doubling as a climbing block for the cheeky kid goat named Ryan.

But E. T. received most of Edgar's affection. They'd take little naps, burrowing into the dog bed together before revving up to play. "E. T. was fascinated by the pig," Pam says. "No question, they had a special connection."

Edgar eventually passed away, just after his seventh birthday. Pam points out that factory-farmed pigs "aren't designed to go on for long." Everyone was in mourning after he died, she says, "even those who hadn't met him. Visitors and our other animals fed off of our sadness. He really touched the lives of so many."

Though her best buddy was gone, Pam says she took great comfort in knowing that he would continue to make a difference for many other animals. "Edgar's memory reminds us not to be prejudiced by the shape or color of another, and that all animals want and deserve

kindness and a feeling of safety. Edgar taught us that if you can't get that from your own species, maybe you can find it in another."

That a pig so drastically changed her own life still amazes Pam, and she's thankful. The 60-acre farm named after Edgar is usually home to some 200 to 300 animals. Soon, the whole shebang is moving to a larger property "because we're busting at the seams," Pam says. "It's an exciting new chapter for all of us."

"It's really lovely to be part of this family," she adds. "I had no idea that what Edgar started would grow so big, rescue so many animals, and change so many hearts."

References

BOOKS, ARTICLES, AND TALKS

Alleyne, Richard, "Can Otters Smell Underwater?" *The Telegraph*, June 5, 2010.

Archer, Rosemary. *The Arabian Horse*. London: J. A. Allen, 1992.

Balcombe, Jonathan. *Second Nature: The Inner Lives of Animals*, New York: Palgrave Macmillan, 2010.

Brach, Tara. "The World in Our Heart" (speech), 4/25/12: imcw.org/Talks/TalkDetail/TalkID/371.aspx.

Denlinger, Milo G. *The Complete Boxer*. New York: Frederick A. Stokes, 1914.

de Waal, Frans. *Good Natured*. Cambridge: Harvard University Press, 1996.

de Waal, Frans. *The Age of Empathy*. New York: Harmony Books, 2009.

Herzog, Hal. *Some We Love, Some We Hate, Some We Eat*. New York: Harper Perennial, 2010.

Holland, Jennifer S. "Bird Guide," *National Geographic*, October 2008.

Holland, Joshua. "In Defense of the Pit Bull," *Salon*, February 5, 2013. salon.com/2013/02/05/in_defense_of_the_pitbull_partner/.

King, Barbara. *How Animals Grieve*. Chicago: University of Chicago Press, 2013.

May, Allyson N. *The Fox-Hunting Controversy, 1781–2004: Class and Cruelty*. Ashgate Publishing, 2013.

Ramos, Kelsey, "Pearls Before Swine: Animal Cognition Study Says Pigs May Be Smarter Than We Think," *Los Angeles Times*, November 11, 2009.

Royal Embassy of Saudi Arabia, "Purebred Arabian Horses Compete in One of the Many Races Organized Exclusively for the Breed in Saudi Arabia": saudiembassy.net/files/PDF/Publications/Magazine/1997-Spring/horse.htm.

Sherman, Josepha. *Trickster Tales: Forty Folk Stories from Around the World*. Atlanta: August House, 2005.

Springett, Martin and Isobel. *Kate and Pippin: An Unlikely Love Story*. New York: Henry Holt and Co., 2012.

SELECT WEB SOURCES

African Mecca: africanmeccasafaris.com

American Kennel Club: akc.org

All About Great Danes: all-about-great-danes.com

Alpacas of Montana: alpacasofmontana.com

American Boxer Club: americanboxerclub.org

American Miniature Horse Association: amha.org

Aragon Alpacas: aragonalpacas.com/alpaca_info.html

BBC Nature: bbc.co.uk/nature

Big Cat Rescue: bigcatrescue.org

Cornell Lab of Ornithology: allaboutbirds.org

Grevy's Zebra Trust: grevyszebratrust.org

Guide Horse Foundation: guidehorse.com
Humane Society of the United States: humanesociety.org
Live Science: livescience.com
National Geographic: nationalgeographic.com
National Zoo: nationalzoo.si.edu
Oklahoma State University Department of Animal Science: ansi.okstate.edu
Out to Africa: outtoafrica.nl
Peregrine Fund: peregrinefund.org
PetWave: petwave.com
Purdue University Food Animal Education Network: ansc.purdue.edu/faen
Rocky Ridge Refuge: rockyridgerefuge.com
Whale Facts: whalefacts.org
Why Pandas Do Handstands: whypandasdohandstands.blogspot.com
Wisconsin National Primate Research Center: pin.primate.wisc.edu
World Wildlife Fund: worldwildlife.org

VIDEOS

"Baby Rhino Calf Finds Friends in the Wild After Abandoned by Mother": youtube.com/
watch?v=tOn2RhH36Mc
"Cat and Owl Playing—Perfect Friendship": youtube.com/watch?v=Iqmba7npY8g

In addition, the author referenced many general-interest resources, including the *Daily Mail*,
Huffington Post, Facebook, *Spiegel*, and Wikipedia.

ADDITIONAL READING

Balcombe, Jonathan. *Pleasurable Kingdom: Animals and the Nature of Feeling Good.*
New York: Palgrave Macmillan, 2007.
Brown, Augustus *Why Pandas Do Handstands.* New York: Free Press, 2010.
Fishkin, Shelley Fisher, ed. *Mark Twain's Book of Animals.* Berkeley: University of California
Press, 2010.
Grandin, Temple, and Johnson, Catherine. *Animals in Translation.* New York: Harcourt, 2005.
Hare, Brian, and Woods, Vanessa. *The Genius of Dogs: How Dogs Are Smarter Than You
Think.* New York: Dutton, 2013.
Mather, Jennifer, Anderson, Roland C., and Wood, James B. *Octopus: The Ocean's Intelligent
Invertebrate.* Portland, OR: Timber Press, 2010.
McConnell, Patricia. *For the Love of the Dog: Understanding Emotion in You and Your Best
Friend.* New York: Ballantine Books, 2007.
Mitchison, John, and Lloyd, John. *The Book of Animal Ignorance: Everything You Think You
Know is Wrong.* New York: Crown, 2008.
Morell, Virginia. *Animal Wise.* New York: Crown, 2013.
Pepperberg, Irene. *Alex & Me: How a Scientist and a Parrot Uncovered a Hidden World of
Animal Intelligence—and Formed a Deep Bond.* New York: Harper, 2008.
Pineño, Oskar. *The Thinking Rat.* CreateSpace Independent Publishing, 2010.
Sheldrake, Rupert. *Dogs that Know When Their Owners are Coming Home.* New York: Three
Rivers Press, 1999.

Acknowledgments

No book is a solo effort, and in this case I am really just a messenger of other people's (and their animals') stories. I owe those people, quoted in these texts, my deepest gratitude for generously sharing their tales with me.

Special thanks to Workman Publishing's Krestyna Lypen for her kind and gentle edit, Melissa Lucier for another heroic effort on the photo front, Raquel Jaramillo and Tae Won Yu for making this book, like *Unlikely Friendships*, such a lovely thing to behold, and Beth Levy for all the copyediting, and finishing fixes and touches. Many thanks also to Jarrod Dyer for the expert typesetting, Maggie Gleason for all the publicity, and everyone else who had a hand in the creation of this book.

Thanks to all the friends and family who sent me story leads—much appreciated!

For taking on research tasks great and small, a huge thank-you to my tireless assistant, Kate Horowitz.

For translations, my gratitude goes to Mariola Maklakiewicz-Carroll, Barbara Büllmann, Steffi Steinberg, and Wanjiku Kinuthia.

For keeping me sane with loving words of encouragement and support, I thank especially Melanie Carlos, Lynne Warren, and Mark Bolander.

Thanks to youngsters Will, Kate, Jasper, and Elliott for being my favorite audience and for keeping my inner child alive and well.

For buying my books by the ton, I am grateful to Lenora Holland and Lorie Holland.

To my husband, John, thanks for being confident in me, proud of what I'm doing, and tolerant of the ups and downs.

To my dogs Tai, Waits, and Monk, I forgive you for all your interruptions, your barking, your constant shedding, and your demands for attention as I tried to write this book. You are my true muses, after all. (Tai, may you rest in peace!)

Jennifer S. Holland